THE
ABC
OF IT

THE ABC OF IT

Why Children's Books Matter

Leonard S. Marcus

Foreword by Lisa Von Drasek

MINNESOTA

Distributed by the University of Minnesota Press
Minneapolis / London

M. LIBRARIES
UNIVERSITY OF MINNESOTA

Copyright 2019 by the Regents of the University of Minnesota
Text copyright 2019 by The New York Public Library
Foreword and Coda copyright 2019 by Lisa Von Drasek

Designed by Lauren Stringer
Contributing editors: Lisa Von Drasek, JoAnn Jonas, Mary Schultz, Lauren Stringer
Text by Leonard S. Marcus reprinted and adapted with permission from The New York Public Library

All rights reserved. No part of this publication may be reproduced, stored in a retrieval system, or transmitted, in any form or by any means, electronic, mechanical, photocopying, recording, or otherwise, without the prior written permission of the publisher.

Published by University of Minnesota Libraries, Children's Literature Research Collections, Kerlan Collection

Distributed by the University of Minnesota Press
111 Third Avenue South, Suite 290
Minneapolis, MN 55401-2520
http://www.upress.umn.edu

ISBN 978-1-5179-0801-0 (pb)

A Cataloging-in-Publication record for this book is available from the Library of Congress.

Printed in Canada on acid-free paper

The University of Minnesota is an equal-opportunity educator and employer

24 23 22 21 20 19 10 9 8 7 6 5 4 3 2 1

Furthermore:
a program of the J.M. Kaplan Fund

The printing of this catalog was made possible by the generous support of Furthermore: a program of the J. M. Kaplan Fund.

The ABC of It: Why Children's Books Matter was originated by

New York Public Library

CONTENTS

- vi — Foreword
- 1 — Introduction
- **4 — VISIONS OF CHILDHOOD**
- 6 — Sinful or Pure? The Spiritual Child
- 10 — A Blank Slate: The Rational Child
- 22 — A Question of Class
- 24 — From Rote to Rhyme
- 30 — The Work of Play: The Progressive Child
- 34 — *Kerlan Features: Goodnight Moon*
- 42 — Building Citizens: The Patriotic Child
- 52 — Down the Rabbit Hole
- 56 — *Kerlan Features: Alice Around the World*
- 60 — In Nature's Classroom: The Romantic Child
- 70 — A Great Dane: Hans Christian Andersen
- 74 — *Kerlan Features: Tenggren Tells-It-Again*
- **78 — OFF THE SHELF: GIVING AND GETTING BOOKS**
- 84 — Gift Books: Visual Splendor
- 94 — *Kerlan Features: The Poky Little Puppy*
- 98 — "Write" Off the Assembly Line
- 104 — No Dogs or Children Allowed
- 106 — *Kerlan Features: Meeting Beatrix Potter*
- 114 — Storyteller en la Biblioteca: Pura Belpré
- 120 — Book Week
- 124 — Lights Out: Reading Under the Covers
- 131 — Censorship: Raising a Ruckus
- **140 — THE ART OF THE PICTURE BOOK**
- 142 — A Master of Motion: Randolph Caldecott
- 150 — A Homespun Expressionist: Wanda Gág
- 152 — *Kerlan Features: Millions of Cats*
- 156 — The Size and Shape of Things
- 164 — The New Leonardo: Bruno Munari
- 168 — *Kerlan Features: Virginia Lee Burton's Little House*
- 180 — Pop Culture
- 182 — Humpty Dumpty
- 185 — *Mary Poppins*
- 186 — *The Secret Garden*
- 188 — *The Wizard of Oz*
- 190 — *The Story of Ferdinand*
- 192 — Harry Potter
- 194 — Comics Grow Up: Graphic Novels
- 198 — *Kerlan Features: Baby Mouse: Queen of the World!*
- 200 — Storied City: New York
- **210 — CODA: FROM THE KERLAN**
- 230 — Suggested Reading
- 231 — Acknowledgments

FOREWORD

Lisa Von Drasek Photo Credit: Paula Keller

What is *The ABC of It*? Although the exhibit's contents cover four centuries of literature, *The ABC of It* is not a strict history of children's books. Rather, it is historian Leonard S. Marcus's thesis on how "books for young people have stories to tell us about ourselves," and that "behind every children's book is a vision of childhood: a shared understanding of what growing up is all about."

When I am giving tours, teaching, traveling, attending conferences, or presenting papers, the question I'm most frequently asked is, "Who was Dr. Kerlan?"

Dr. Irvin Kerlan, an alumnus of UMN, was a staff doctor at the Food and Drug Administration in Washington, D.C. He was also a collector of rare children's books, original art, and manuscripts. One only has to read *Dear Dr. Kerlan* by Jean Stevenson, PhD, to gain a sense of his passion for the work of children's book artists and illustrators and of their respect for his objective to preserve the process of children's book making.

The year 2019 is a milestone for the Children's Literature Research Collections, as it marks the 70th anniversary of Dr. Kerlan's first gift to the University of Minnesota.

Dr. Irvin Kerlan

The first curator of the Kerlan Collection was Karen Nelson Hoyle, PhD. Her care of Dr. Kerlan's collection would have been a significant accomplishment on its own, but for 43 years Dr. Hoyle also maintained relationships with authors and illustrators and developed new ones, identifying the best of the best to be included in one of the finest repositories of rare children's books and related manuscripts and art.

Allow me to digress for a moment. In 1916, Lucy Sprague Mitchell founded what is now the Bank Street College of Education. Mitchell's work with children

Karen Nelson Hoyle, PhD

Lucy Sprague Mitchell with grandchildren

and teachers informed her teaching, which in turn informed her writing. And it was there, at the Writers Lab, that teachers, librarians, and writers witnessed the foundations of modern children's literature. And it was there, embedded in the college's progressive curriculum, that I practiced my teacher/librarian craft for 15 years while Dr. Hoyle was curating, researching, and writing.

It is all connected. In 1992, as a publishing assistant, I read *Margaret Wise Brown: Awakened by the Moon* by Leonard S. Marcus. Marcus wove together the threads of social history, the history of progressive education, and the history of children's literature, elucidating his original research to paint a unique portrait of this significant author from the Writers Lab. Twenty-one years later, I spent hours poring over case labels in The New York Public Library's exhibition hall, immersed in *The ABC of It: Why Children's Books Matter*, the show Marcus curated for the NYPL. With materials pulled from across its collections, *The ABC of It* was a wild success—the most highly attended NYPL exhibit, it was extended twice, running from June, 2013 to September, 2014.

But what about those who didn't make it to New York City, and those of us who wish we could have returned just one more time? We at the Kerlan Collection dreamed of adapting Marcus's text to pair with the Kerlan materials, and it is with enormous gratitude that we thank The New York Public Library, for permission to adapt its impressive exhibit for this new one, using Marcus's intellectual framework and insightful (and sometimes wry) descriptions. Our exhibit explores the impact of children's literature in society and culture over time, using more than 200 books, pieces of original artwork and correspondence, and other materials selected from the University of Minnesota Archives and Special Collections.

—Lisa Von Drasek, Curator
Children's Literature Research Collections

INTRODUCTION

The entrance of The New York Public Library

For 14 months starting in June of 2013, more than half a million visitors streamed through the main gallery of The New York Public Library to view an exhibition about the role that children's books play in world culture and our lives. A favorite childhood book will often leave a deep and lasting personal impression, but as adults we tend to shelve such memories alongside countless others as we go about the business of living. As the curator of *The ABC of It: Why Children's Books Matter*, my goal was to entice exhibition goers to look again at our first books as part of a larger and perhaps less familiar story: to consider children's books across time and national borders as reflections of the adult world's changing ideas about childhood, as carriers of a culture's hopes and dreams, and as expressions of a vibrant art form that is rarely as simple as it seems.

The realization that childhood literacy is a key to a better life is one of the modern world's signal achievements. Children's books have flourished wherever a rising middle class sought to provide for its children's future, and it is no great surprise that the West's first epicenter of children's book publishing activity was the dynamic eighteenth-century city of London. (Less well known to Westerners is the comparable trade in illustrated books for young readers that developed independently, and at almost the same time, halfway around the world in Edo, Japan—the sprawling commercial city now called Tokyo.)

Kyokutei Bakin, Edo-era, digital version
Waseda University Library, Japan

English philosopher John Locke helped set the stage when, in *Some Thoughts Concerning Education* (1693), his broadly influential guide to all aspects of child-rearing, he detailed his plan for the ideal book for young readers. Locke's idea—that a children's book should be attractively illustrated, not overlong, and a pleasure rather than a chore to read—laid the groundwork for the literature we

now take for granted. Within a few decades' time, another visionary Londoner, John Newbery, had put Locke's template to the test as a pioneering publisher and bookseller in the commercial trade in children's books that has since grown into a global enterprise.

The story of children's literature's origins and coming of age is itself a tale with memorable characters and plot turns. There were writers—from Hans Christian Andersen and Lewis Carroll—to E.B. White and Madeleine L'Engle who safeguarded a place for wonder in a world increasingly dominated by mechanistic styles of thought, and artists like Beatrix Potter and Maurice Sendak who devoted their extraordinary talents to revealing to children not only the exhilarating

Detail from *Orbis Sensualium Pictus*. See page 18

beauty of life but also its bracing intensity. There were philosophers like Locke, Jean-Jacques Rousseau, Johann Comenius, and John Dewey who, as pathfinding interpreters of the phenomenon of childhood, inspired major strands of bookmaking and storytelling for the young. There were the librarians who devised rigorous standards for evaluating children's

Drawing of Dr. Irvin Kerlan, Book Collector, by Don Freeman

books and effective ways of putting good books into children's hands, and educators who proposed radically different ideas about what those good books should be like. There were the publishers who came to embrace juvenile publishing as a core activity after first having approached it, often warily, as a marginal obligation. And then, too, there were pioneering collectors of children's book art, manuscripts, correspondence, and ephemera—the University of Minnesota's Dr. Irvin Kerlan being a superb example—without whose foresight and persistence much of this story would have been lost forever.

I am deeply grateful to the Kerlan Collection of the University of Minnesota's Andersen Library for giving renewed life

to *The ABC of It* by merging the curatorial plan and gallery text I created for The New York Public Library with the university's own fabled collections. To cite just one of numerous illustrations of this alchemical collaboration, it is wonderful this time around to be able to demonstrate the shapeshifting influence of American progressive educators on the invention of books for children of the youngest ages by exhibiting original art from two of the seminal contributions to that genre: *Goodnight Moon* and *A Hole Is to Dig*.

long ago, only to realize, as Lloyd Alexander wisely observed: "On the level of high art, in their common efforts to express human truths, relationships, attitudes, and personal visions, children's literature and adult literature meet and sometimes merge, and we wonder then whether a given work is truly for children or truly for grown-ups. The answer, of course, is: for both."

—Leonard S. Marcus

Detail from *A Hole Is to Dig*. See page 39

The wish to provide children with books capable of inspiring a lifelong love of reading is felt more keenly around the world today than at any time in the past. The value of regarding that literature in its totality, as both a rich repository of collective memory and a powerful engine of cultural change, has accordingly never been greater either. These books have so much to say. As a visitor to *The ABC of It* and reader of this catalog, you may well catch yourself being unaccountably drawn back to pictures and words you thought you had outgrown

Leonard S. Marcus reviewing selections for *The ABC of It*

Introduction 3

VISIONS
OF
CHILDHOOD

Are children born innocent or sinful? Empty-headed or wise? Should they be "seen and not heard," as an old adage recommends, or granted free rein to play as raucously as they wish? Should they be taught to think and act as good citizens?

Behind every children's book is a vision of childhood: a shared understanding of what growing up is all about. Accordingly, authoritative voices from the realms of theology, philosophy, psychology, and education have all played their part in shaping the nature of literature for young people.

Puritan minister Cotton Mather urged the Bible on children at the earliest possible age. But Mather's near contemporary, philosopher John Locke, believed that a reading life best began with books "apt to delight and entertain," such as Aesop's fables. Jean-Jacques Rousseau dismissed Locke's advice, arguing that the young needed "the bare truth," not tales that "cover truth with a veil," and that preteens were in fact better off reading the "book of nature," by which he meant their own experience.

Today, experts disagree just as vigorously about the good or harm attributable to the fantasy—or frank realism—found in contemporary books. Now as then, when visions of childhood clash, literature for young people becomes anything but child's play.

Sinful or Pure?
The Spiritual Child

Some early juvenile books addressed the state of the young person's soul. A Puritan child, considered sinful at birth, could not hope to achieve salvation without first learning to read the Bible. *The New England Primer*—for 100 years the most widely known juvenile book in North America—gave young New Englanders who lived, as Cotton Mather wrote, "under the dreadful Wrath of God," the very stepping-stone they needed to set them on the right path.

But what if one believed, like William Blake, that a child was born not sinful but wonderstruck, and spiritually knowing? Self-published in a first printing of 16 copies that he sold at his own shop, Blake's *Songs of Innocence*, a diminutive hand-bound volume of illustrated lyric poems, proved to be immensely powerful, pointing the way for generations of children's writers and artists, from Hans Christian Andersen to Maurice Sendak, whose young heroes radiate inner knowledge and strength, and are unafraid to say when the emperor has no clothes.

The New England Primer
Boston: S. Kneeland & T. Green, 1843 (circa 1690)
3.75" x 4.75"
Kerlan Collection, Children's Literature Research Collections, University of Minnesota Libraries

This unremarkable-looking little volume is the most influential American children's book of the 18th and early 19th centuries. First published in Boston around 1690, *The New England Primer* represented to pious Puritan parents nothing less than the prospect of spiritual salvation for their sons and daughters. It offered instruction leading to the ability to read the Bible—the only book of real significance, they believed. And it prepared the young (should they survive past their first years in an age of dismally high child mortality) for a prayerful life. Later editions—by 1830 there were more than 430—were modified to make note of changing worldly concerns. The alphabet rhyme for "K" in a 1727 edition, for instance, read, "Our King the Good/No Man of Blood," but by 1791, a new sentiment was clearly in order: "The British King/Lost States Thirteen."

THE NEW ENGLAND PRIMER;

OR,

AN EASY AND PLEASANT GUIDE

TO

THE ART OF READING.

Adorned with Cuts.

TO WHICH IS ADDED

THE CATECHISM.

MASSACHUSETTS SABBATH SCHOOL SOCIETY,
Depository No. 13 Cornhill, Boston.
1843.

NEW ENGLAND PRIMER.

ALPHABET.

a b c d e f g h i j
k l m n o p q r s t
u v w x y z &

*a b c d e f g h i j
k l m n o p q r s t
u v w x y z &*

A B C D E F G H I J
K L M N O P Q R S T
U V W X Y Z

*A B C D E F G H I J
K L M N O P Q R S T
U V W X Y Z*

DOUBLE LETTERS.

ff fi fl ffi ffl *ff fi fl ffi ffl*

Time cuts down all
Both great and small

Uriah's beauteous wife
Made David seek his life.

Whales in the sea
God's voice obey.

Xerxes the Great did die,
And so must you and I.

Youth forward slips,
Death soonest nips.

Zaccheus, he
Did climb the tree,
His Lord to see.

T U V W X Y Z

AN ALPHABET OF LESSONS FOR CHILDREN.

A WISE son makes a glad father, but a foolish son is the heaviness of his mother.

BETTER is a little, with the fear of the Lord, than great treasure, and trouble therewith.

COME unto Christ, all ye who labor and are heavy laden, and he will give you rest.

DO not the abominable thing which I hate, saith the Lord.

EXCEPT a man be born again, he cannot see the kingdom of God.

FOOLISHNESS is bound up in the heart of a child, but the rod of correction will drive it from him.

GRIEVE not the Holy Spirit, lest it depart from thee.

HOLINESS becomes God's house forever.

IT is good for me to draw near unto God.

KEEP thy heart with all diligence, for out of it are the issues of life.

LIARS will have their part in the lake which burns with fire and brimstone

Visions of Childhood

Songs of Innocence
William Blake
London: Ernest Benn, 1926 (1789)
7" x 10"
Kerlan Collection, Children's Literature Research Collections, University of Minnesota Libraries
This edition of Blake's *Songs of Innocence* is reproduced from a copy in the British Museum, has been printed and made in Great Britain, and was first published in the year 1926 by Ernest Benn, Ltd., Bouverie House, Fleet Street, London.
Colophon: Facsimile of 1789 edition printed by William Blake.

One of English art and poetry's visionary outliers, William Blake recalled having seen, "as early as four . . . God press His face against the window pane." To him, there was nothing the least bit extraordinary about this: children, Blake believed, were spiritual guides, untarnished souls with ready access to the essential nature of things. He codified his vision of childhood in *Songs of Innocence,* a slender collection of lyric poetry that he wrote, designed, illustrated, printed, and hand colored, the latter with help from his wife, Catherine. He sold the book in his London print shop, originally from an edition of just 16 copies.

Songs of Innocence greatly influenced latter-day picture book artists with its organic blending of image and text. Blake was convinced that children would find much to appreciate in its quick-silver pages as well. He was far less certain about grown-ups.

Visions of Childhood

The Little Boy found

The little boy lost in the lonely fen,
Led by the wand'ring light,
Began to cry, but God ever nigh,
Appeard like his father in white.

He kissed the child & by the hand led
And to his mother brought,
Who in sorrow pale, thro' the lonely dale
Her little boy weeping sought.

Visions of Childhood

A Blank Slate: The Rational Child

Enlightenment philosopher John Locke pictured a newborn's mind as a tabula rasa, or blank slate primed for learning, and believed that a child's capacity for reason increased naturally over time. Locke argued that earnest Puritans who exhorted their four-year-olds to read the Bible failed to realize that children so young might simply not be up to the task. What books were suitable? In *Orbis Sensualium Pictus (The Pictured World)*, educator Johann Amos Comenius was among the first to show that illustration worked wonders to concentrate a young reader's attention. Endorsing this view, Locke, in *Some Thoughts Concerning Education*, added humor, brevity, and a reasoned appeal for good behavior to his trail-blazing checklist of children's literature dos and don'ts. Let the young relish—and reflect on—Aesop's fables, Locke declared; let "Learning be made . . . a Play and Recreation." Locke's recommendations helped spawn an unprecedented demand for children's books and educational games, an opportunity that publisher-booksellers from London to New England enthusiastically seized.

Some Thoughts Concerning Education
John Locke
London: A. and J. Churchill, 1699 (1693)
6" x 7.75"
Wilson Library, University of Minnesota Libraries

"If I mis-observe not, [children] love to be treated as rational Creatures sooner than is imagined," wrote John Locke in this seminal reflection on education in the broadest sense. Locke believed that teaching by rote or fear ran counter to children's fundamental nature. Reasoning alone was not enough, however. Early education worked best when the child experienced it as a form of play: "Thus Children may be . . . taught to read, without perceiving it to be any kind of thing but a Sport, and play themselves into that which others are whipp'd for."
Authoritative statements such as this gave 18th century printer-publishers in Britain, continental Europe, and North America their new marching orders, and primed like-minded parents to shop for juvenile books unlike any they had seen before.

SOME THOUGHTS CONCERNING Education.

*Doctrina vires promovet insitas,
Rectiq; cultus pectora roborant:
Utcunq; defecere mores,
Dedecorant bene nata culpæ.*

Hor. L. IV. Od. 4.

The Fourth Edition Enlarged.

LONDON,

Printed for *A.* and *J. Churchill*, at the Black Swan in Pater-noster-row, 1699.

Of EDUCATION.

Drink. I once lived in an House, where, to appease a froward Child, they gave him *Drink* as often as he cried; so that he was constantly bibbing: And tho' he could not speak, yet he drunk more in Twenty four Hours than I did. Try it when you please, you may with Small, as well as with Strong Beer, drink your self into a Drought. The *Habits.* great Thing to be minded in Education is, what *Habits* you settle: And therefore in this, as all other Things, do not begin to make any Thing *customary*, the Practice whereof you would not have continue, and increase. It is convenient for Health and Sobriety, to *drink* no more than Natural Thirst requires: And he that eats not Salt Meats, nor drinks Strong Drink, will seldom thirst between Meals, unless he has been accustomed to such unseasonable *Drinking*.

Strong Drink. §. 19. Above all, Take great Care that he seldom, if ever, taste any *Wine*, or *Strong Drink*. There is nothing so ordinarily given Children in *England*, and nothing so destructive to them. They ought *never* to drink any *Strong Liquor*, but when they need it as a Cordial,

Cordial, and the Doctor prescribes it. *Strong* And in this Case it is, that Servants *Drink.* are most narrowly to be watched, and most severely to be reprehended, when they transgress. Those mean Sort of People, placing a great Part of their Happiness in *Strong Drink*, are always forward to make Court to my young Master, by offering him that, which they love best themselves: And finding themselves made merry by it, they foolishly think 'twill do the Child no Harm. This you are carefully to have your Eye upon, and restrain with all the Skill and Industry you can; There being nothing that lays a surer Foundation of Mischief, both to Body and Mind, than Children's being used to *Strong Drink*; especially, to drink in private, *with the Servants*.

§. 20. *Fruit* makes one of the most *Fruit.* difficult Chapters in the Government of Health, especially that of Children. Our first Parents ventur'd *Paradise* for it: And 'tis no Wonder our Children cannot stand the Temptation, though it cost them their Health. The Regulation of this cannot come under any one General Rule. For I am by no Means

Visions of Childhood 11

Aesop's Fables
Ernest Griset, illustrator
Boston: Lee and Shepard.
New York: Charles T. Gillingham, 1878
6″ x 8.5″
Wilson Library, University of Minnesota Libraries

Collections of the pithy morality tales attributed to Aesop, a Greek slave of the 6th century B.C., are among the earliest printed books in the West. Aesop's fables are also among the most frequently illustrated of all literary texts. The first illustrated edition, printed in Ulm in 1476, was not intended for children, and artists both outside and within the children's book world have continued to draw inspiration from the fables' nutshell narratives and unadorned wisdom.

The Lion's Paw
Jane Werner Watson; Gustaf Tenggren, illustrator
New York: A Big Golden Book, 1960 (1959)
9.4" x 12.75"
Kerlan Collection, Children's Literature Research Collections,
University of Minnesota Libraries

Fables
Arnold Lobel
New York: Harper & Row, 1980
8.4" x 12"
Kerlan Collection, Children's Literature Research Collections,
University of Minnesota Libraries

Aesop's Fables
Jerry Pinkney
New York: SeaStar Books, 2000
8.9" x 11.8"
Kerlan Collection, Children's Literature Research Collections,
University of Minnesota Libraries

Aesop's Fables (following pages)
Jerry Pinkney
cover art: digital reproduction used with permission of the artist

Visions of Childhood 13

RULES FOR BEHAVIOUR IN CHILDREN.

CHAP. I.
Mixt PRECEPTS.

1. FEAR GOD and believe in CHRIST.
2. Honour the Magistrates.
3. Reverence thy Parents.
4. Submit to thy Superiours.
5. Despise not thy Inferiours.
6. Be courteous with thy Equals.
7. Pray daily and devoutly.
8. Converse with the Good.
9. Imitate not the Wicked.

RULES *for* BEHAVIOUR. 95

10. Hearken diligently to Instruction.
11. Be very desirous of Learning.
12. Love the School.
13. Be always neat and cleanly.
14. Study Virtue and embrace it.
15. Provoke no Body.
16. Love thy School Fellows.
17. Please thy Master.
18. Let not Play entice thee.
19. Restrain thy Tongue.
20. Covet future Honour, which only Virtue and Wisdom can procure.

CHAP. II.
Containing One Hundred and Sixty three Rules for Children's Behaviour, viz.

At the MEETING HOUSE.
At HOME.
At the TABLE.
In COMPANY.
In DISCOURSE.
At the SCHOOL.
When ABROAD; and
When among OTHER CHILDREN.

A Little Pretty Pocket-Book
Worcester, Mass.: Isaiah Thomas, 1787 (1744)
Op page image 1767 edition.
2.5" x 4"
Kerlan Collection, Children's Literature Research Collections, University of Minnesota Libraries

Guided by the Lockean principle that the best children's books entertain while instructing, London publisher John Newbery issued the first of many such texts, A Little Pretty Pocket-Book, in 1744. Newbery's offerings struck a chord with forward-thinking parents, and the English market for children's trade books was born.

In 1779, a savvy Massachusetts printer named Isaiah Thomas began selling imported copies of the Newberys in his shops. When the supply ran out, he printed more—including the volume shown here—under his own name, which, in the days before international copyright protection, was not illegal. Thomas, who died one of the new republic's most respected cultural figures, was later hailed as the "American Newbery."

A Little Pretty Pocket-Book was the first volume published for children by John Newbery of London. Of the edition, June 1744, no single copy has survived. The 1st American edition was published by Isaiah Thomas at Worcester, Mass., in 1787.

(75)

A little Boy *and* Girl *reading.*

ALL good Boys and Girls take care to learn their Lessons, and read in a pretty Manner; which makes every Body admire them.

Orbis Sensualium Pictus
(The Pictured World)
Johann Amos Comenius; illustrator unknown
London: J. Kirton, 1659 (1658)
3.5" x 5.5"
From the collection of an anonymous donor

Among the very first illustrated books published expressly for children, this stout volume first compiled in 1658 by renowned Moravian educator Johann Amos Comenius is the precursor to modern-day junior picture encyclopedias. The original Nuremberg edition appeared in Latin and German. The first Latin and English edition followed one year later. Comenius had advanced ideas about education that John Locke and others would later amplify. He recognized the impact of illustration on children's understanding and believed that learning should build outward from the familiar. Although spiritual matters received due attention in Comenius's "pictured world," his most famous book gave pride of place to worldly matters—geography, weather, plants, animals, and machinery, among others.

(30)

XIV.

Fruits of Trees. **Fructus Arborum.**

Fruits that have no
shels are pulled from
fruit-bearing trees:
 The Apple 1.
is round.
 The Pear 2.
and Fig 3.
are somewhat long.
 The Cherry 4.
hangeth
by a long start.
 The Plumb 5.
and Peach 6.

Poma
ab arboribus fructiferis
decerpuntur.
 Malum 1.
est rotundum.
 Pyrum 2.
& Ficus 3.
sunt oblonga.
 Cerasum 4.
pendet
longo Pediolo ;
 Prunum 5.
& Persicum 6.

(31)

The Mulberry 7.
a very short one.
The Wall-nut 8.
The Hasel-nut 9.
The Chest-nut 10.
are wrapt in a
[husk]
[and] a shell.
[Barren] Trees
[ar]e 11.
[Th]e Firr,
[Th]e Elder,
[Th]e Birch,
[Th]e Cypress,
[Th]e Beech,
[Th]e Ivy,
[Th]e Sallow,
[Th]e Linde tree, &c.
[yi]eld the most of them
[affor]ding shade.
[But th]e Juniper 12.
[and] Bay-tree 13.
[yield]
[berr]ies.
[The] Pine 14.
[Pi]ne-Apples.
[The] Oak 15.
[Ac]orns
[and] Galls.

breviori ;
 Morum 7.
brevissimo.
 Nux juglans 8.
Avellana 9.
& Castanea 10.
involuta sunt
Cortici
& Putamini.
 Steriles arbores
sunt 11.
Abies,
Alnus,
Betula,
Cupressus,
Fagus,
Fraxinus,
Salix,
Tilia, &c.
sed pleræque
umbriferæ.
 At *Juniperus* 12.
& Laurus 13.
ferunt
 Baccas ;
 Pinus 14.
Strobilos.
 Quercus 15
Glandes
& Gallas.

Flowers

Road to the Temple of Honour and Fame
Handcolored etching
London: John Harris, 1810
New York Public Library Digital Collections,
Rare Book Division
Gameboard cover: 21.25" x 36"
Gameboard: 17.5" x 22.25"

In this board game with ornate architectural detail, players are led by stages to discover that "the most exalted situations in life may be gained by good conduct and attention to learning." Indeed!

20 Visions of Childhood

Visions of Childhood 21

A Question of Class

Children typically have not had equal access to the literature published for them. The groundbreaking juvenile books brought to market by John Newbery in mid-18th-century London were unaffordable by England's working-class families. A century later, as the branch of publishing that Newbery helped pioneer continued to grow and diversify, children's books came increasingly to reflect differences in the economic and social status of their intended readers.

For upwardly mobile, middle-class English children of the 1840s, an aspirational work such as *The Royal Alphabet of Kings and Queens,* celebrating the lives of historical personages of extraordinary destiny, might count as a prized possession. But for children of the working poor, books like *Instructions on Needlework and Knitting* served the more pragmatic purpose of teaching a marketable skill. Least likely of all to benefit from the proliferation of Victorian-era children's books were the tens of thousands of truly destitute youngsters who begged in the streets and received, at best, a modicum of free education at one of the charitable "Ragged Schools" first established in London in 1844.

The Royal Alphabet of Kings and Queens
John Gilbert, illustrator
London: Joseph Cundall, 1843 (1841)
Harvard University Library, Hathi Trust, Digital Library, Public Domain, Google digitized

22 Visions of Childhood

Sample Book
Handmade sample book of stitchery skills
Boyle School, 1840
7" x 15"
In private collection

This book might easily be mistaken for a luxury gift item for girls. In fact, it was published for use by girls enrolled in a charity school, for the purpose of conferring "upon the Children of the Poor the Inestimable Benefit of Religious Instruction"—and to send its charges into the world armed with a useful trade. By 1851, England and Wales had a combined total of 17,000 such so-called national schools serving an estimated 955,000 students.

Visions of Childhood

From Rote to Rhyme

Books fostering basic literacy skills date from ancient times. In the United States, two series had extraordinary staying power: the morality-laced McGuffey Reader series of the 19th century, whose eponymous creator was hailed by Abraham Lincoln as the "schoolmaster of the nation," and the mid-20th-century adventures of Dick and Jane.

At the peak of their popularity during the postwar Baby Boom, Dick and Jane readers reached 85% of America's public schoolchildren, with their idealized vignettes of white, middle-class suburban life. Educators praised the books for their contemporary, child-centered focus. Not everyone agreed, however. Journalist John Hersey condemned the series's "abnormally courteous, unnaturally clean boys and girls," and reading specialist Rudolf Flesch called the books "pointless" and worse.

Responding to the outcry, and to Cold War America's rising fear of Soviet educational superiority, an editor-friend of Dr. Seuss dared him to create a "supplementary reader [that] first graders can't put down." With the publication of *The Cat in the Hat*, learning to read became uproarious fun as never before.

McGuffey's New Fourth Eclectic Reader
William Holmes McGuffey
Cincinnati: Van Antwerp, Bragg & Co, 1879 (1836)
5.5" x 7.5"
Kerlan Collection, Children's Literature Research Collections, University of Minnesota Libraries

In widespread use in U.S. schools between the mid-19th and early 20th centuries, this series of graded primers ranks with the Bible and Webster's dictionary among the bestselling books of all time. Their originator, William Holmes McGuffey, was the son of Scottish immigrants and a dedicated teacher. McGuffey replaced rote memorization as the key to basic literacy with a phonics approach that allowed children to build on their experiences. The more advanced volumes, such as the one displayed here, featured literary excerpts selected with a view to challenging schoolchildren intellectually and to instilling good Christian values.

I. PERSEVERANCE.

1. "WILL you give my kite a lift?" said my little nephew to his sister, after trying in vain to make it fly by dragging it along the ground. Lucy very kindly took it up and threw it into the air, but, her brother neglecting to run off at the same moment, the kite fell down again.

(25)

3. Part of the kernels flew one way,
 And a part hopped out the other;
Some flew plump into the sister's lap,
 Some under the stool of the brother;
The little girl gathered them into a heap,
And called them a flock of milk-white sheep.

VI. SMILES.

1. POOR lame Jennie sat at her window, looking out upon the dismal, narrow street, with a look of pain and weariness on her face. "Oh, dear," she said with a sigh, "what a long day this is going to be," and she looked wishfully up the street.

Visions of Childhood 25

Let the pupil practice these examples until he is perfectly familiar with the rising and falling inflections.

Are you sick´, or well`? Will you go´, or stay`?

Did he ride´, or walk`? Is it black´, or white`?

Is he rich´, or poor`? Are they old´, or young`?

Did you say cap´, or cat`? I said cat`, not cap´.

Did you say am´, or ham`? I said ham`, not am´.

Is the dog white´, or black`? The dog is black`, not white´. Did you say and´, or hand`? I said and`, not hand´. Is the tree large´, or small`? The tree is small`, not large´. Are the apples sweet´, or sour`? The apples are sour`, not sweet´. Is the tide high´, or low`? The tide is high`, not low´. Did you say play´, or pray`? I said pray`, not play´.

McGuffey's New Fourth Eclectic Reader
William Holmes McGuffey
Cincinnati: Van Antwerp, Bragg & Co, 1879 (1836)

Lak'ota pte'ole hokšila lowansa: Wo'unspe t'okahe (Singing Sioux Cowboy)
Ann Nolan Clark; Emil Afraid-of-Hawk, translator; Andrew Standing Soldier, illustrator
Lawrence, Kans.: United States Indian Service, 1947
7" x 10"
Wilson Library, University of Minnesota Libraries

Lakota Sioux such as George Defender won fame as rodeo cowboys during the early decades of the last century. This collection of songs and verses suitable for elementary school children celebrated that proud tradition while offering students on the Pine Ridge reservation (in South Dakota) a chance to hone their reading skills in both the Lakota and English languages.

Bowwow Powwow
Brenda J. Child; Gordon Jourdain, translator; Jonathan Thunder, illustrator
10.5" x 10.8"
St. Paul, MN: Minnesota Historical Society Press, 2018
Kerlan Collection, Children's Literature Research Collections, University of Minnesota Libraries

Gii-Tagoshinowaad Mayagi-Waagoshag (When the White Foxes Came)
Bizhikiis, Ningaabii'anook, Animikiigiizhigookwe, and Waabishkii-miigwan
Hayward, WI: Grassroots Indigenous Multimedia, 2017
8" x 8"
Kerlan Collection, Children's Literature Research Collections, University of Minnesota Libraries

Visions of Childhood

Photo of Theodor Geisel (Dr. Seuss)
by Al Ravenna, World Telegram staff photographer
Library of Congress. New York World-Telegram & Sun Collection. http://hdl.loc.gov/loc.pnp/cph.3c24309, Public Domain, https://commons.wikimedia.org/w/index.php?curid=1273914
Library of Congress, Prints and Photographs Division, LC-USZ62-124309

The Cat in the Hat
Dr. Seuss [Theodor S. Geisel]
New York: Random House, 1957
7" x 9.5"
Kerlan Collection, Children's Literature Research Collections, University of Minnesota Libraries

The Cat in the Hat Comes Back
Dr. Seuss [Theodor S. Geisel]
New York: Random House, 1958
7" x 9.5"
Kerlan Collection, Children's Literature Research Collections, University of Minnesota Libraries

Theodor S. Geisel—known as Dr. Seuss to his legions of sticky-fingered young fans—was a favorite picture-book author when a former army buddy turned publishing executive approached him with a daunting challenge. Starting from a list of about 300 "sight words" that five- and six-year-olds could be counted on to recognize, Seuss was asked to conjure a text capable of transforming America's youngsters into readers for life.

The public enthusiastically embraced *The Cat in the Hat* as a winsome riposte to Dick-and-Jane-style monotony. The book's popularity spawned not only a sequel but also a new publishing company—Beginner Books—with Seuss at the helm, and with P. D. Eastman and the Berenstains soon lending their talents as key contributors.

28 Visions of Childhood

We Look and See
William S. Gray, Dorothy Baruch, and
Elizabeth Rider Montgomery;
Eleanor Campbell, illustrator
Chicago: Scott, Foresman and Company, 1946–47 edition,
Basic Readers: Curriculum Foundation Series
5.8" x 7.8"
Gift of Barbara Neihart to the Kerlan Collection
(Interior from Anniversary Marketing Materials)

For 40 years, school books about Dick and Jane—young suburbanites with sunny dispositions and placid, predictable lives—taught millions of American first graders to read. Introduced in 1930, the ubiquitous readers were updated every five years. Until the mid-1960s, when the series' popularity was already in decline, both text and illustrations presented an all-white portrait of middle-class American life.

The major role assigned to illustration in the series, as well as its systematic reliance on short words and familiar storylines, demonstrated a greater sensitivity to child-centered learning than had comparable books of the previous century. Nevertheless, by the 1950s, it was clear from national test results that the Dick and Jane books were not doing their job. Writing in *Life*, journalist John Hersey asked why school texts of such pivotal importance could not have real literary merit, and why they could not be illustrated by an "imaginative genius" like Dr. Seuss.

Come, Dick.
Come and see.
Come, come.
Come and see.
Come and see Spot.

Look, Spot.
Oh, look.
Look and see.
Oh, see.

Visions of Childhood

The Work of Play: The Progressive Child

The rise of child psychology around 1900 inspired "progressive" educators to reimagine schooling from a child's perspective. What if, as John Dewey proclaimed, "learning by doing" better suited a child's natural capabilities than rote memorization? What if play, said Maria Montessori, was not idleness but the work of childhood?

At New York's progressive Bank Street School, Lucy Sprague Mitchell's pioneering language-development studies prompted a vigorous challenge to the common wisdom about books for the youngest ages. Her *Here and Now Story Book* asserted that preschoolers craved not fairy tales, but stories about the world they knew, as well as books that invited their playful, collaborative participation. Mitchell's literary protégée Margaret Wise Brown led the charge in putting these revolutionary ideas into practice, most famously in *Goodnight Moon*. An impressive array of artists lent their talents as well, including Edward Steichen, Jean Charlot, Maurice Sendak, and Crockett Johnson, whose unflappable doodler Harold gave Mitchell's movement its poster child.

Lucy Sprague Mitchell
Lucy Sprague Mitchell at typewriter, (no date)
Bank Street College of Education Archives,
Bank Street College of Education

HERE AND NOW STORY BOOK

INTRODUCTION

These stories are experiments,—experiments both in content and in form. They were written because of a deep dissatisfaction felt by a group of people working experimentally in a laboratory school, with the available literature for children. I am publishing them not because I feel they have come through to any particularly noteworthy achievement, but because they indicate a method of work which I believe to be sound where children are concerned. They must always be regarded as experiments, but experiments which have been strictly limited to lines suggested to me by the children themselves. Both the stuff of the stories and the mould in which they are cast are based on suggestions gained directly from children. I have tried to put aside my notions of what was "childlike." I have tried to ignore what I, as an adult, like. I have tried to study children's

Here and Now Story Book
Lucy Sprague Mitchell; Hendrik Willem van Loon, illustrator
New York: E.P. Dutton & Co., 1928 (1921)
5.5" x 7.75"
Kerlan Collection, Children's Literature Research Collections, University of Minnesota Libraries
(Interior pages used with permission)

Part manifesto, part model for a new approach to writing for preschoolers, this volume by the founder of the Bank Street College of Education became a hotly debated bestseller upon its publication. Lucy Sprague Mitchell argued that the fairy tales then favored by librarians confused young children, who naturally craved stories about their own here-and-now world, skyscraper cities and all. Mitchell staked her claim on years of direct observation of children at the Bank Street School. Librarians retorted that literature was an art, not a science. While the library viewpoint remained dominant for years to come, Mitchell's provocation inspired Margaret Wise Brown, Ruth Krauss, and others to take the picture book in exciting new directions.

MARNI TAKES A RIDE IN A WAGON

One day Marni went for a ride. Little Aa, he climbed into Sprague's wagon and Marni, she climbed in behind him. Then Mother took the handle and she began to pull the wagon with little Aa and Marni in it. And Mother she went:

 Jog, jog, jog, jog,
 Jog, jog, jog, jog,
 Jog, jog, jog, jog,
 Jog, jog, jog, jog,
And Jog, jog, jog, jog,
 Jog, jog, jog, jog,
 Jog, jog, jog, jog,
 Jog!

And the wheels, they went, (with **motion of hands**):

 Round, round, round, round,
 Round, round, round, round,
 Round, round, round, round,
 Round, round, round, round,
And Round, round, round, round,
 Round, round, round, round,
 Round, round, round, round,
 Round!

And then Mother was tired. So **she stopped**. And Marni said, "Whoa, horsie!"

Visions of Childhood

The First Picture Book
Mary Steichen Martin and Edward Steichen
New York: Harcourt, Brace & Co., Inc., 1930
7.25" x 8.5"
Kerlan Collection, Children's Literature Research Collections, University of Minnesota Libraries

Edward Steichen created the photographs for this book for two-year-olds at the prompting of his daughter, Mary Steichen Martin. A visit to the Bank Street nursery school had made her an ardent believer in Lucy Sprague Mitchell's theory that the very young are "little empiricists" who live intensely in the world of their immediate surroundings. Just as the "unit blocks" pictured here were designed to offer such children "open-ended" play experiences, the left-hand pages of the book were kept text-free, the better for parent and child to improvise their own commentary. Other Steichen subjects include a clock, a telephone, and a pair of socks—everyday objects later reprised in the Great Green Room of *Goodnight Moon*.

Visions of Childhood

The Noisy Book
Margaret Wise Brown; Leonard Weisgard, illustrator
New York: William R. Scott, Inc., 1939
8" x 9.75"
Kerlan Collection, Children's Literature Research Collections,
University of Minnesota Libraries

This early picture book experiment by the author of *Goodnight Moon* sets in motion a game-like narrative that invites both the reading adult and the listening child to mimic the raucous street noises heard by a dog named Muffin. The call-and-response pattern all but guarantees an uproarious experience and the realization of a key progressive objective: the full involvement of children in their own learning and play.

The Seashore Noisy Book
Margaret Wise Brown; Leonard Weisgard, illustrator
New York: William R. Scott, Inc., 1941
8" x 9.75"
Kerlan Collection, Children's Literature Research Collections,
University of Minnesota Libraries

The Indoor Noisy Book
Margaret Wise Brown; Leonard Weisgard, illustrator
New York: William R. Scott, Inc., 1942
8" x 9.75"
Kerlan Collection, Children's Literature Research Collections,
University of Minnesota Libraries

Visions of Childhood

GOODNIGHT MOON

GOODNIGHT MOON

by Margaret Wise Brown

Pictures by Clement Hurd

Goodnight Moon
Margaret Wise Brown; Clement Hurd, illustrator
New York: Harper & Brothers, 1947
process and finished art including book cover
cover, tempera on board, 8.3" x 7" (opp)
process art, pencil and tempera on board, 17" x 10" (top)
process art, pen and ink wash on board, 13.25" x 12.5" (bottom)
finished art, tempera on board, 17" x 10.75" (next page)
Kerlan Collection, Children's Literature Research Collections, University of Minnesota Libraries

A student of Mitchell's in the mid-1930s, Margaret Wise Brown arrived at Bank Street a gifted but mercurial and undisciplined writer. She left a published author of the utmost originality, and with a thorough grounding in the child-development theories that Mitchell had helped pioneer. In the lulling mantra that is *Goodnight Moon*, Brown fashioned the quintessential "here and now" bedtime ritual, evoking a small child's safe and secure world. Life's everyday necessities—food, clothing, and shelter—are all present and accounted for. In the best progressive manner, children are themselves encouraged to bid goodnight to each of them in turn, thereby making the Great Green Room their own.

GOOD NIGHT ROOM

A Hole Is to Dig: A First Book of First Definitions
Ruth Krauss; Maurice Sendak, illustrator
New York: Harper & Brothers, 1952
Dimensions 5.5" x 6.75"
Kerlan Collection, Children's Literature Research Collections, University of Minnesota Libraries

The inspiration for this small but consequential book came from Yale University child psychologist Arnold Gesell's observation that a five-year-old "is a pragmatist. His definitions are in terms of use: A horse is to ride; a fork is to eat." In 1950, Ruth Krauss began collecting more such definitions—in part at the Bank Street School—and then invited the unknown young artist her publisher had paired her with to choose which definitions he wished to illustrate. *A Hole Is to Dig* became Maurice Sendak's breakthrough success and marked the start of a fruitful, decade-long collaboration with Krauss.

A Hole Is to Dig: A First Book of First Definitions
Maurice Sendak, illustrator
process art, pen and ink on paper
cover sketch, 4" x 3" (bottom)
Cats are to have kittens, 5.25" x 6.8" (opp, top L)
Cats are to have kittens, 2" x 1.65" (opp, top R)
Children reading, 2" x 1.5" (opp, center L)
Dramatic child, 1" x 1" (opp, center R)
A hole is for a mouse to live in, 2" x 2.25" (opp, bottom L)
Snow is to roll in, 5" x 3.33" (opp, bottom R)
Kerlan Collection, Children's Literature Research Collections, University of Minnesota Libraries

Visions of Childhood

Visions of Childhood 39

The Phantom Tollbooth
Norton Juster; Jules Feiffer, illustrator
New York: Epstein and Carroll, 1961
6.5" x 9.5"
Kerlan Collection, Children's Literature Research Collections, University of Minnesota Libraries

The young hero who journeys to the allegorical Lands Beyond and back starts out as a bored school child and returns home with his eyes and mind open wide to the world. What accounts for Milo's extreme makeover? Not tollbooth magic so much as a series of Oz- or Alice-like encounters with walking paradoxes, human riddles, and other ridiculous obsessives. These and other absurdities test Milo's wits as he learns, in the best progressive way, to chart his own path to Rhyme and Reason—and to trust his own ideas.

Harold and the Purple Crayon
Crockett Johnson
New York: Harper & Brothers, 1955
5" x 6"
Kerlan Collection, Children's Literature Research Collections, University of Minnesota Libraries

This book's sly opening scene—designed to look as if Harold himself has scribbled over the page—cannot have pleased many librarians. The story that follows, however, clearly shows that Crockett Johnson's hero is not a defacer of public property but rather a young person with imagination to spare. As Harold calmly wields his crayon to remake the world according to his wants and wishes, he exemplifies the confident, self-starting child whom progressive educators like Lucy Sprague Mitchell dedicated themselves to nurturing. Aptly for a story with deep roots in the Bank Street School's "here and now" philosophy, Harold's ultimate destination is a city.

Harold's Fairy Tale
Crockett Johnson
New York: Harper & Brothers, 1956, 5" x 6"

Harold at the North Pole
Crockett Johnson
New York: Harper & Brothers, 1958, 5" x 6"

Harold's Trip to the Sky
Crockett Johnson
New York: Harper & Brothers, 1957, 5" x 6"

Harold's Circus
Crockett Johnson
New York: Harper & Brothers, 1959, 5" x 6"

A Picture for Harold's Room
Crockett Johnson
New York: Harper & Brothers, 1960, 6" x 8.5"
Kerlan Collection, Children's Literature Research Collections, University of Minnesota Libraries

Building Citizens: The Patriotic Child

In new nations and those undergoing radical transition, books for young people become unifying civic tools. In his ubiquitous spellers, Noah Webster introduced a distinctly American English language—freed from what he described as the clamor of British aristocratic affectation—to generations of the young republic's schoolchildren. Revolutionary Russia's state-run publishers enlisted artists and writers to create picture books that embellished guideposts of good civic behavior with aesthetic delight. The long-smoldering Irish republican independence movement sparked a revival of interest in Irish fairy tales, in which the poets William Butler Yeats and James Stephens played leading roles. Paperbacks in comic-book format proved wildly effective in familiarizing Occupation-era Japanese children with Western cultural ideals, and postcolonial India's youth with their nation's labyrinthine cultural heritage. Currently, postcolonial French West Africa is in the early stages of a process that Webster would have recognized: the effort to craft authentically African children's books that, as the Cameroon-born artist Christian Épanya has said, "speak" to African children.

The American Spelling Book
Noah Webster
New York: Bureau of Publications,
Teachers College, Columbia University, (1783), reprint of the 1831 ed. Published by William H. Niles, Middletown, Conn.
4" x 7"
Wilson Library, University of Minnesota Libraries
Originally printed in Boston by Isaiah Thomas and Ebenezer T. Andrew, 1793

A Yale undergraduate during the Revolutionary War years, Noah Webster was an ardent patriot who, soon after independence, found his calling as the author of American schoolbooks for American children. He yearned for an American English purged of what he believed to be the excesses of British aristocratic influence.
Aiming for democratic clarity in spelling and grammar, Webster succeeded in removing the "u" from "favour" and "honour," though his alternative for "neighbor," "nabor" never took hold. During the 1800s, as many as 100 million copies of Webster's spellers were in circulation. Most of these, however, were pirated editions from which the author himself did not profit. Webster is best known today as the author of the first major American dictionary.

The American Spelling Book; Containing The Rudiments of The English Language for the Use of Schools in the United States (interior, top R)
Noah Webster
Hartford, CT: Hudson and Company, 1822

Noah Webster (opp, bottom)
The Schoolmaster of the Republic
Born 1758—died 1843
Published: c1891
Library of Congress Prints and Photographs Division, Washington, D.C. 20540 USA

42 Visions of Childhood

Visions of Childhood 43

He might think, as he stared on a staring horse, "a boy cannot wag his tail to keep the flies off." (Page 40)

Irish Fairy Tales
James Stephens; Arthur Rackham, illustrator
New York: Macmillan and Co., reissued 1968 (1920)
6.25" x 8"
Kerlan Collection, Children's Literature Research Collections, University of Minnesota Libraries

Publisher Frederick Macmillan proposed this volume to James Stephens in 1918, and the writer was immediately receptive: "I shall do the Fairy Tale book you suggest with the greatest pleasure . . . I have been working indeed on Irish Folklore, custom, history & fairy stuff so your proposition comes to me on the top of the tide."

Two years after the violent Easter Rising that failed to bring an end to English rule over Ireland, Stephens was keen to employ his talents to preserve traditional Irish culture from British imperialist influence. Though he later insisted that children were not his intended audience, this storybook soon became a staple of juvenile library collections.

44 Visions of Childhood

In My Mother's House
Ann Nolan Clark; Velino Herrara, illustrator, also known as
Ma Pe Wi, Oriole, Red Bird, Velino Herrara, Velino Shije
New York: Viking, 1941
8.75" x 10.5"
Kerlan Collection, Children's Literature Research Collections,
University of Minnesota Libraries

Ann Nolan Clark was an educator employed by the United States Bureau of Indian Affairs. Her books for young readers, starting with this one from 1941, played a key role in the implementation of the federal government's new, more culturally respectful approach to the education of Native American children. Velino Herrera was a Native American artist from Zia Pueblo, New Mexico. Shown here is his stylized depiction of ritual Corn Dancers and life-giving rain.

Visions of Childhood 45

**Daniel Boone: Les aventures d'un chasseur Américain parmi les peaux-rouges
(Daniel Boone: Historic Adventures of an American Hunter Among the Indians)**
Esther Averill; Feodor Rojankovsky, illustrator
Paris: Domino Press, 1931
11.5" x 14.75"
Kerlan Collection, Children's Literature Research Collections, University of Minnesota Libraries

In December 1930, the French magazine *Art et décoration* lamented the fact that France had fallen far behind the United States, England, and Russia in the quality of its children's books. Ironically, it was the appearance the following year of this illustrated narrative of American pioneering life that finally reignited French publishers' determination. Issued in both French- and English-language editions, *Daniel Boone* was the handiwork of an American expatriate living in Paris and a Russian illustrator who later made his way to New York.

La Calle es Libre
Kurusa; Monika Doppert, illustrator
Ediciones Ekaré, 1981
8.8" x 7.9"
On loan from the collection of Leonard S. Marcus

Published in Venezuela in 1981 by the nonprofit Ediciones Ekaré and loosely based on real events, this inspiring picture book describes the efforts of a group of barrio children who petitioned the Caracas city government for a safe park in which to play. The local library, which serves both as a source of books and as a community-building gathering place, closely resembles those founded by the literacy organization of which Ekaré is the publishing offshoot—Venezuela's world-renowned Banco del Libro, or Book Bank.

46 Visions of Childhood

Feng Zikai ji
(Feng Zikai Collection) Feng Zikai
Beijing: Dong fang chu ban she, 2008
6.5" x 9"
On loan from the collection of Leonard S. Marcus

Chinese artist, essayist, and educator Feng Zikai came to prominence during the 1920s, thanks in part to the lyrical manhua, or cartoon collections, he created for and about children. Influenced by Western Romanticism, Zikai believed that the traditional emphasis in Chinese children's books on discipline and rote learning did not serve the nation's larger needs. This recent compilation of Zikai's drawings signals a renewed interest in his work, and comes one year after the establishment in China of the Feng Zikai Picture Book Award, a prize intended to foster the development of a new children's literature informed by Zikai's philosophy.

The Bicycle Man
Allen Say
Oakland, Calif.: Parnassus, 1982
9.75" x 9"
Kerlan Collection, Children's Literature Research Collections, University of Minnesota Libraries

Allen Say grew up in Yokohama during and after World War II. He based this picture book about a visit by two friendly American GIs to a Japanese grade school on his own childhood memories of life in Occupied Japan. However, in his 1994 Caldecott Medal acceptance speech for *Grandfather's Journey*, Say mused on the tricks memory can play, citing a grammar school reunion he attended in 1982: "Nineteen classmates came to the party. . . . I handed out copies of *The Bicycle Man*. . . . No one remembered the incident. . . . They looked at me with embarrassment and incomprehension, even pity. Then they laughed and called me Urashima Taro, the fisherman of the ancient folktale who returns home after being away for four hundred years"—and finds that nothing is as he remembers it.

Visions of Childhood

Amar chitra katha (Immortal Picture Stories): "Krishna Retold from the Bhagawat Puran"
Anant Pai, series creator
Bombay [Mumbai]: H.G. Mirchandani for India Book House Education Trust, 1982–1983
6.75" x 9.7"
On loan from the collection of JoAnn Jonas

Since the late 1960s, comic books in the hugely popular Amar chitra katha (Immortal Picture Stories) series have introduced tens of millions of English-speaking, predominantly middle-class Indian youngsters to their religious and cultural roots. Anant Pai (known as "Uncle Pai" to generations of adoring fans) launched the venture after observing a boy on a television quiz show who could answer every question about Greek mythology but was unable to name the mother of Rama, the 7th avatar of Vishnu.

Amar chitra katha (Immortal Picture Stories): "Ganesha the Remover of all Obstacles"
Anant Pai, series creator
Bombay [Mumbai]: H. G. Mirchandani for India Book House Education Trust, 1982–1983
6.75" x 9.7"
On loan from the collection of JoAnn Jonas

Visions of Childhood

Tsunami
Joydeb and Moyna Chitrakar
Thiruvanmiyur, Chennai, India: Tara Books, 2011 (2009)
14.6" x 6" (closed) 14.6" x 68" (opened-accordion)
pictured: front cover (top), back cover (center),
accordion-pages (opp)
On loan from the collection of Lauren Stringer

This picture book is cast in the narrative scroll format of the traditional Patua art style of West Bengal, in southeast India. Remarkable for its vibrancy as a work of graphic art and design, it links past and present by memorializing the tragic devastation of the 2004 Indian Ocean tsunami while at the same time evoking powerful echoes of ancient flood myths such as the one set down in the Hindu text *Satapatha Brahmana*.

50 Visions of Childhood

Visions of Childhood 51

Down the Rabbit Hole

Alice's Adventures in Wonderland began life casually, as a story improvised during a summertime boating excursion to amuse three young daughters of an Oxford dean. The storyteller, a mathematics lecturer and cleric named Charles Dodgson, placed the girl who had requested it, 10-year-old Alice Liddell, at the center of his helter-skelter tale, which blithely skewered authority in all its guises, from schoolmasters and kings to know-it-all moral-mongers. Dodgson later presented his muse with a keepsake manuscript—"Alice's Adventures Under Ground"—illustrated with his own rough-hewn drawings and a photographic portrait of the real Alice, also by him.

As word of the irreverent fantasy spread, Dodgson succumbed to friends' urgings and published an expanded version under his pen name, Lewis Carroll, and with illustrations by England's preeminent satirical artist, John Tenniel. Alice Liddell grew up to lead a conventional Victorian married life, but her namesake gave literature a new kind of hero: the fearless young adventurer with curiosity to spare.

Portrait of Alice Liddell as "The Beggar Maid"
Lewis Carroll [Charles Lutwidge Dodgson]
Handcolored albumen print, 1858
Dodgson, C. (1859) The Beggar Maid, Public Domain

Lewis Carroll purchased his first camera in 1856 and soon became an accomplished amateur portrait photographer. Though he photographed adult subjects, including Lord Tennyson and the Prince of Wales, his strong preference was always for girls. As Carroll observed (prompting later cynics—and psychoanalysts—to wag their tongues), "It is very healthy and helpful to one's spiritual life, and humbling, too, to come into contact with souls so much purer and nearer to God, than one feels oneself to be." In this portrait, he evinced the same fascination with childhood impishness and impetuosity that he showed when he sent Alice's fictive namesake down the rabbit hole to a world beyond all predictability and reason.

Alice's Adventures Underground
Lewis Carroll [Charles Lutwidge Dodgson]
Thirty-seven illustrations by the author
Christ's Church College, Oxford, Oxfordshire, 1862–64
Held by British Library, Public Domain

Visions of Childhood 53

Alice's Adventures in Wonderland
Lewis Carroll [Charles Lutwidge Dodgson];
John Tenniel, illustrator
London: Macmillan and Co., 1870 (1865)
5" x 7.6"
Kerlan Collection, Children's Literature Research Collections,
University of Minnesota Libraries

Lewis Carroll presented a special copy of *Alice's Adventures in Wonderland* to the child friend for whom he wrote the book. Carroll had sent Alice Liddell an earlier, vellum bound copy—the very first off the press—directly from the binder in early July, 1865. But he soon recalled that copy, along with several more sent to other friends, when illustrator John Tenniel expressed alarm over major flaws in the printing. Bowing to Tenniel's criticisms, Macmillan ordered a "second" edition, which became the first to be offered for sale in England. Rather than destroy the botched initial press run, however, the publisher sold it off to the New York firm of Appleton on the theory that American readers were too coarse to know the difference between good printing and bad.

54 Visions of Childhood

AND A LONG TALE.

so that her idea of the tale was something like this:——"Fury said to
> a mouse, That
> he met
> in the
> house,
> 'Let us
> both go
> to law :
> *I* will
> prosecute
> *you*.—
> Come, I'll
> take no
> denial ;
> We must
> have a
> trial :
> For
> really
> this
> morning
> I've
> nothing
> to do.'
> Said the
> mouse to
> the cur,
> 'Such a
> trial,
> dear sir,
> With no
> jury or
> judge,
> would be
> wasting
> our breath.
> 'I'll be
> judge,
> I'll be
> jury,'
> said
> cunning
> old Fury ;
> 'I'll try
> the whole
> cause,
> and
> condemn
> you
> to
> death.'

ALICE AROUND THE WORLD

Fushigi no kuni no Arisu
Alice's Adventures in Wonderland
Lewis Carroll; S Nagasawa, translator
Tokyo: Gaikokugo Kenkyusha, 1934.
4.45" x 7" (top, opp)
Kerlan Collection, Children's Literature Research Collections,
University of Minnesota Libraries

Alice's Adventures in Wonderland
Lewis Carroll; Iassen Ghiuselev, illustrator
Italy: Simply Read Books, 2003
9.6" x 13" (bottom, opp L)
Kerlan Collection, Children's Literature Research Collections,
University of Minnesota Libraries

Alice I Underlandet
Lewis Carroll; Tove Jansson, illustrator
Stockholm: Albert Bonniers, 1966
6.3" x 9.25" (bottom, opp center)
Kerlan Collection, Children's Literature Research Collections,
University of Minnesota Libraries

Alice au pays des merveilles
Lewis Carroll; Guy Tredez, translator;
Adrienne Segur, illustrator
France: Flammarion, 1949
9.75" x 13" (bottom, opp R)
Kerlan Collection, Children's Literature Research Collections,
University of Minnesota Libraries

Alice's Adventures in Wonderland
Lewis Carroll; Anthony Browne, illustrator
New York: Knopf, 1988
7.6" x 11.25" (top, R)
Kerlan Collection, Children's Literature Research Collections,
University of Minnesota Libraries

Lewis Carroll's Alice's Adventures in Wonderland
Lewis Carroll; Barry Moser, illustrator
Berkeley: Univ of Calif Press, 1982
18.25" x 13.5" (bottom, R)
Kerlan Collection, Children's Literature Research Collections,
University of Minnesota Libraries

Alizah beerets hapela'ot Alice's Adventures in Wonderland
Lewis Carroll
Israel: Fratelli Fabri
8.8" x 12"
Kerlan Collection, Children's Literature Research Collections,
University of Minnesota Libraries

Alice Csodaországban
Lewis Carroll;
Kosztolányi Dezső, translator;
Szegedi Katalin Rajzaival, illustrator
Budapest: General Press Kiadó, 2007
8" x 11.3"
Kerlan Collection, Children's Literature Research Collections,
University of Minnesota Libraries

Alicia en el País del Espejo
Lewis Carrol; Juan José Llobet, translator;
Aurelia Cuschie, illustrator
Buenos Aires: Editorial Acme, 1957
5" x 7.5"
Kerlan Collection, Children's Literature Research Collections,
University of Minnesota Libraries

Alice in Wonderland
Lewis Carroll; Marie Laurencin, illustrator
Paris: Black Sun, 1930
11" x 9.5", lithograph
Kerlan Collection, Children's Literature
Research Collections,
University of Minnesota Libraries

Alice's Adventures in Wonderland
Lewis Carroll; DeLoss McGraw, illustrator
New York: HarperCollins, 2001
8" x 9"
Kerlan Collection, Children's Literature
Research Collections,
University of Minnesota Libraries

In Nature's Classroom: The Romantic Child

A pivotal figure linking the Enlightenment and Romanticism, Jean-Jacques Rousseau believed that children under 12 lacked the power of reason. Until then, books could only confuse them. "Reading is the scourge of childhood," proclaimed the firebrand philosopher with his customary flair.

In Émile, Rousseau delineated an ideal, book-free education with nature as the child's only classroom. Ironically, the image of the "natural child" he thus popularized quickly morphed into one of children's literature's dominant themes. William Blake, Nathaniel Hawthorne, Hans Christian Andersen, and, a century later, E. B. White all wrote for and about young people who were better attuned than their elders to the wonders of the natural world. The Grimms—Romantic scholars of the pre-Enlightenment past—first collected old-fashioned "wonder tales" as cultural relics worthy of study. Soon, book-buying parents were embracing the brothers' *Household Tales* as juvenile gift-book gold, its stories capable of transporting their children into the wild wood of their imagination.

George Cruikshank's Fairy Library
George Cruikshank
Etchings, 1853–64
Facsimile edition reproduced from the Osborne Collection of Early Children's books, Toronto Public Library, 1981
5.5" x 7"
Kerlan Collection, Children's Literature Research Collections, University of Minnesota Libraries

George Cruikshank gave his all to the depiction of the fearsome ogre of "Hop-o'-My-Thumb," a trickster tale first published in France in Charles Perrault's *Histoires ou contes du temps passé*. In the set-up scene shown here, Cruikshank presents the youngest of a poor woodcutter's seven children as the least likely of heroes. Later, in a reversal of fortune sure to delight child readers, small but quick-witted Hop proves to have more than enough tricks up his sleeve to save himself and his entire family.

Visions of Childhood

Speaking Likenesses (title page and illustration)
Christina Rossetti; Arthur Hughes, illustrator
London: Macmillan, 1874
5" x 7"
Kerlan Collection, Children's Literature Research Collections, University of Minnesota Libraries

The Pre-Raphaelites, a circle of English poets, writers, artists, and critics to which both Christina Rossetti and Arthur Hughes belonged, carried into the latter half of the 19th century some of English Romanticism's central concerns. Among these was a fascination with childhood as a time of innocence and unfettered spiritual clarity. Hughes's gold-stamped cover decoration for Rossetti's juvenile storybook is at once an intimate domestic vignette and an image shot through with a sense of spiritual radiance.

Speaking Likenesses (cover)
Christina Rossetti; Arthur Hughes, illustrator
London: Macmillan, 1874
5" x 7"
held by British Library, Public Domain

Visions of Childhood

Sleeping Beauty
Arthur Rackham
London: William Heinemann, 1920
7.75" x 10.25"
Kerlan Collection, Children's Literature Research Collections,
University of Minnesota Libraries

As the illustrator of *Sleeping Beauty*, Arthur Rackham made a rare departure from the richly dramatic pictorial style for which he was known. The 65 silhouettes he created for that volume, edited by Charles S. Evans and originally published in 1920, rank with his freshest and most playful work.

Visions of Childhood

Slovenly Peter, or Happy Tales and Funny Pictures
Heinrich Hoffmann; Mark Twain, translator;
Fritz Kredel, illustrator
Chicago: Donohue & Henneberry, 1898
9.25" x 12.75"
Kerlan Collection, Children's Literature Research Collections,
University of Minnesota Libraries

This volume of wickedly funny pictures and rhymes has been called Germany's greatest contribution to children's literature after Grimms' fairy tales. It started as the homemade creation of a Frankfurt doctor. At Christmastime, 1844, Heinrich Hoffmann went shopping for a book for his three-year-old son. Finding none that was not either sickly sweet or excessively moralizing, he returned home with a blank notebook instead, and fashioned this over-the-top parody of the fright-inducing cautionary tales of the day. Hoffmann's son was hardly alone in getting the joke. Published anonymously the following year, the book was an instant success. In 1891, Mark Twain produced the third English language translation, *Slovenly Peter, or Happy Tales and Funny Pictures*. Some readers, however, have always taken Slovenly Peter literally and come away with nightmares, not liberating laughs.

66 Visions of Childhood

Where the Wild Things Are
Maurice Sendak
New York: Harper & Row, 1963
10.5" x 9.5"
Kerlan Collection, Children's Literature Research Collections,
University of Minnesota Libraries

The 20th century's preeminent children's book artist, Maurice Sendak was a lifelong student of Romanticism. William Blake and the Grimms loomed large in his pantheon of creative influences. In *Where the Wild Things Are,* Max in his wolf suit seems a cunning cross between Blake's lamb and tiger: one part innocence, one part rage. In his fearless exploration of childhood emotion, Sendak also introduced Freud into the mix. *In Where the Wild Things Are,* the forest of fairy tales becomes a persuasive metaphor for the dreaming unconscious, the place where demons can be faced down and life's balance ultimately restored.

Visions of Childhood

Charlotte's Web
E. B. White; Garth Williams, illustrator
New York: Harper & Brothers, 1952
5.5" x 8.25"
Kerlan Collection, Children's Literature Research Collections, University of Minnesota Libraries

E. B. White was a late Romantic who described this, his second children's book after *Stuart Little*, as a "hymn to the barn"—a paean to the transcendent beauty of nature. He grants seven-year-old Fern the capacity to comprehend the farm animals, while adults are too easily distracted by tricks like Charlotte's writing in her web. Were the spider's "Some pig," "Terrific"—signs from above? In White's estimate, sooner or later most everyone loses sight of the fact that nature itself is the miracle. White wrote *Charlotte's Web* while reporting on the founding of the United Nations for *Harper's* magazine. In the atomic age, he recognized, the earth was perishable and in need of protection. What could save it? Wise leaders like Charlotte, or a world forum like this story's barnyard, where even a rat may realize the sense of keeping the web intact.

The author of *Charlotte's Web* grew up in suburban Mount Vernon, New York, and spent much of his early adult life living in Manhattan. In 1933, he and his wife, Katharine, bought a farm in Maine, a vacation getaway that later became their year-round home. White wrote *Charlotte's Web* with his Maine farm squarely in mind.

Some Writer, The Story of E. B. White
Melissa Sweet; afterword by Martha White
New York: Houghton Mifflin Harcourt, 2016
7.3" x 9.25"
Kerlan Collection, Children's Literature Research Collections, University of Minnesota Libraries

process art, (opp)
mixed media, 18" x 12"
used with permission of the artist

"Where's Papa going with that ax?" said
her mother as they were sitting down to breakfast. They were in
the kitchen having breakfast.

"Out to the hoghouse," replied Mrs. Arable. "Some
pigs were born last night."

"I don't see why he needs an ax," continued
who was only eight. xxxxxxxx

"Well," said her mother, xxxxxxxx they were
pigs were born, and one of them is a runt — just a little
thing. Your father will have to do away with it. It's no

"Do away with it?" screamed Fern. "You mean
it? Just because it's smaller than the others?"

Visions of Childhood 69

A Great Dane: Hans Christian Andersen

"Life itself," wrote Hans Christian Andersen, the first great modern fantasist for children, "is the most wonderful fairy tale." Like his own Ugly Duckling, the hopelessly gawky Danish storyteller underwent an extraordinary transformation: from poor provincial lad to globetrotting celebrity. Inspired in part by the traditional "wonder tales" collected by the Brothers Grimm, Andersen boldly fashioned new stories that reclaimed a place for the magical in a world that increasingly prized science and reason as the measure of all things.

Where, according to Andersen, might magic lie? In the ocean's depths, where humans dared not venture ("The Little Mermaid"); at home, late at night, when toys were free to act out their destinies ("The Steadfast Tin Soldier"); and in overlooked nooks and crannies ("Thumbelina"). A Romantic to the core, Andersen believed that children, with their wide-eyed receptivity to life, were the likeliest to recognize the wonder that was, in fact, everywhere around us.

Hans Christian Andersen
Thora Hallager, 1869
Wikimedia Commons

A Fully Cut Fairytale
Hans Christian Andersen, Circa 1864
Cut paper, 13.5" x 13.25" (opp-bottom)
The Elisha Whittelsey Collection, The Elisha Whittelsey Fund and Mary Martin Fund, 2012, Public Domain

70 Visions of Childhood

The Amazing Paper Cuttings of Hans Christian Andersen
Beth Wagner Brust
New York: Ticknor & Fields, 1994
8.25" x 9"
Kerlan Collection, Children's Literature Research Collections, University of Minnesota Libraries

As Andersen's fairy tales grew ever more popular, their author became one of the modern world's first international celebrities, and a much sought-after houseguest of the rich and titled of Europe. In return for the lavish hospitality accorded him, Andersen was usually willing to perform a program of stories for his hosts and their friends. If children were present, he might embellish the recitation by taking scissors in hand and improvising cut-paper illustrations like those reproduced here. The many such paper cuts that survive reveal another, lesser-known side of Andersen: the visual artist of astonishing inventiveness, wit, and technical virtuosity.

Visions of Childhood

The Steadfast Tin Soldier
Hans Christian Andersen; adapted by Tor Seidler;
Fred Marcellino, illustrator
New York: HarperCollins, 1992
Kerlan Collection, Children's Literature Research Collections,
University of Minnesota Libraries

Fred Marcellino first rose to prominence as a bookjacket artist, dominating the field for more than a decade with his iconic designs for such international best sellers as Tom Wolff's *The Bonfire of the Vanities,* Margaret Atwood's *The Handmaid's Tale,* and Anne Tyler's *The Accidental Tourist.* Then, in midcareer, he turned to illustrating children's books, an art form that satisfied his keenness for storytelling. Marcellino was, like Andersen, an ardent fan of the ballet. Of the origins of this, his second picture book, the artist recalled, "I was introduced to this story by way of George Balanchine's ballet of the same name, set to music by Bizet. Such a very tender story, but [also] dark and wickedly funny. . . . Just my cup of tea."

The Little Mermaid Illustration from The Stories of Hans Christian Andersen (opp)
Edmund Dulac, illustrator
London: Hodder & Stoughton, ca. 1910–14
Kerlan Collection, Children's Literature Research Collections,
University of Minnesota Libraries

French-born painter Edmund Dulac moved to London at the turn of the last century, just as the demand for luxury illustrated gift editions was skyrocketing. In the decade and a half that followed, Dulac's sumptuous palette, luminous sense of light, and fertile gift for make-believe served him well as the illustrator of the *Arabian Nights Tales*, Shakespeare's *The Tempest,* and Andersen's fairy tales. In this exquisitely painted scene from Andersen's "The Little Mermaid," the story's heroine saves the life of the human prince with whom she has fallen hopelessly in love.

The Little Mermaid
Hans Christian Andersen; Anthea Bell, translator;
Lisbeth Zwerger, illustrator
New York: Penguin, 2004
Kerlan Collection, Children's Literature Research Collections,
University of Minnesota Libraries

An Austrian artist and recipient of the international Hans Christian Andersen Medal in illustration, Lisbeth Zwerger has made a specialty of refreshing classic tales with her ethereal watercolors. Zwerger's *The Little Mermaid*, which first appeared as a traditional picture book in 2004, hews more closely to Andersen's original three-hanky love story than does the more upbeat Disney version.

Visions of Childhood

TENGGREN TELLS-IT-AGAIN

The Tenggren Tell-It-Again Book
Text edited and adapted by Katharine Gibson;
Gustaf Tenggren, illustrator
Little Brown & Co., Boston, 1942
8.5" x 11"
Kerlan Collection, Children's Literature Research Collections,
University of Minnesota Libraries

Rapunzel
Grimms; Gustaf Tenggren, illustrator
watercolor and gouache on board
10.35" x 13"
Kerlan Collection, Children's Literature Research Collections,
University of Minnesota Libraries

Tenggren

Cinderella
Grimms; Gustaf Tenggren, illustrator
watercolor and gouache on board
6.4" x 10" (opp, top L)
Kerlan Collection, Children's Literature Research Collections,
University of Minnesota Libraries

The Shoemaker and the Elves
Grimms; Gustaf Tenggren, illustrator
watercolor and gouache on board
9.5" x 6" (opp, top R)
Kerlan Collection, Children's Literature Research Collections,
University of Minnesota Libraries

Snow White and Rose Red
Grimms; Gustaf Tenggren, illustrator
watercolor and gouache on board
12.4" x 8.25" (opp, bottom)
Kerlan Collection, Children's Literature Research Collections,
University of Minnesota Libraries

The Ugly Duckling
Hans Christian Andersen; Gustaf Tenggren, illustrator
watercolor and gouache on board
21" x 7.5" (top)
Kerlan Collection, Children's Literature Research Collections,
University of Minnesota Libraries

Thumbelina (under mushroom)
Hans Christian Andersen; Gustaf Tenggren, illustrator
watercolor and gouache on board
10.25" x 10.8"
Kerlan Collection, Children's Literature Research Collections,
University of Minnesota Libraries

Thumbelina (with bird)
Hans Christian Andersen; Gustaf Tenggren, illustrator
watercolor and gouache on board
10.25" x 8.8"
Kerlan Collection, Children's Literature Research Collections,
University of Minnesota Libraries

OFF THE SHELF: GIVING AND GETTING BOOKS

With rare exceptions, adults not only create and publish what young people read but also serve as their literature's gatekeepers, determining what children can—and cannot—access.

As literacy rates skyrocketed in the 19th century, juvenile books and magazines, including some of spectacularly beautiful design, became gifts of choice in education-minded households throughout the industrialized world. Victorians, influenced by the era's Arts and Crafts Movement, cobbled together clever homemade storybooks as unique tokens of affection that occasionally found a wider audience—none more famously than Lewis Carroll's *Alice's Adventures in Wonderland*.

Around 1900, America's young people became the world's first to enjoy access to public libraries. The oasis-like Children's Rooms that later generations would take for granted first opened their doors, and children's librarianship emerged as a new, activist profession concerned with both the accessibility and the quality of juvenile books.

Adults, of course, have not always had the last word. Adventure-laced "dime novels," first sold at mid-19th-century tobacco shops, fueled the fantasy lives of generations of teens, who could often afford to buy the reputedly vile and disreputable paperbacks with their own pocket change. From the 1930s, 10-cent comics gave school children a thrilling forbidden literature of their own to pore over in secret.

Dime Novels

Hess Collection
Children's Literature Resource Collections
University of Minnesota LIbraries

Top row:
Tip Top Weekly Frank Merriwell's Crew or The Champions of the Potomac - No. 76.
New York: Street and Smith, September 25, 1897

The Army and Navy Library - Vol. 1, No. 4.
New York: The Army Navy Publishing Company

The Jesse James Stories - No. 108.
New York: Street and Smith, 1903

Pluck and Luck, Complete Stories of Adventure
No. 35. New York: Frank Tousey, Feb. 1, 1899

Waverley Library, A Wild Girl or Love's Glamour
Vol. VI, No.151. New York: Beadle and Adams, Oct. 3, 1882

Center row:
Fireside Novelist, Noel's Romance - Vol.1, No.5.
New York: Robert Jackson, Jan. 14, 1886

The Leisure Hour Library - Vol.III, No. 252.
New York: F. M. Lupton, July 20, 1889

Red White and Blue - Vol.1, No. 7.
New York: Street and Smith, Dec. 19, 1896

The Brookside Library - The Grass Widow
No. 135. New York: Frank Tousey, 1891

New York Five Cent Library - Dead Shot Dave in Tacoma - No. 33. New York: Street and Smith, March 25, 1893

Bottom row:
Tip Top Library - Frank Merriwell's Venture or Driven From Armenia - Vol. 1 No.33.
New York: Street and Smith, November 28, 1896

Good News - Best Stories From Every Quarter: The Treasure of the Golden Crater - Vol. 6, No.144. New York: Street and Smith, Feb. 4, 1893

Waverley Library - Through Fire and Water - Vol. IV, No.100. New York: Beadle and Adams, Oct. 11, 1882

Buffalo Bill Stories - A Weekly Publication Devoted to Border History - No.223.
New York: Street and Smith, 1905

The Boys of New York - A Paper for Young Americans - Vol. XIII, No.627. New York: Frank Tousey, Aug. 20, 1887

Off the Shelf: Giving and Getting Books

Off the Shelf: Giving and Getting Books 81

Baby's Opera
Walter Crane
New York, McLoughlin Bros., 1877
7.75"x 7.5"
Kerlan Collection, Children's Literature Research Collections, University of Minnesota Libraries

A prominent Victorian illustrator, designer, and educator associated with William Morris and England's Arts and Crafts Movement, Walter Crane was the most popular picturebook artist of his day.

St. Nicholas Illustrated Magazine for Boys and Girls, Volume 41, No. 1
New York: The Century Co. 1913
6" x 8.8"
Kerlan Collection, Children's Literature Research Collections, University of Minnesota Libraries

Monthly children's magazines flourished in the economically expansive decades following the American Civil War. Foremost among these was *St. Nicholas*, which launched in 1873 under the editorship of Mary Mapes Dodge, famed author of *Hans Brinker*. Dedicated to banishing dreary moralizing from juvenile fare and to giving young Americans their first solid exposure to literature and art, Dodge recruited contributions from Louisa May Alcott, Mark Twain, and L. Frank Baum, among others, and from such top-drawer illustrators as Frederic Remington, Howard Pyle, and Palmer Cox. In 1899, the magazine added the St. Nicholas League, a contest-driven department to be written and illustrated by its young subscribers. The roster of future luminaries who broke into print in the League's pages is astonishing: E. B. White, Katharine Sergeant (White), Edmund Wilson, F. Scott Fitzgerald, Edna St. Vincent Millay, Eudora Welty, and Rachel Carson, to name a few.

Gift Books: Visual Splendor

Children's books become gifts of choice wherever an educated middle class is on the rise. In England, the juvenile trade formed in the 1740s when London bookseller-printer John Newbery latched on to the surging demand for children's fare that mingled instruction with delight, as John Locke had recommended. By the early 1700s, a comparable juvenile book trade had developed independently in Edo, Japan.

As advances in color printing upped the ante on visual splendor, sumptuous gift editions of children's classics illustrated by noted artists Arthur Rackham, Ivan Bilibin, and others became holiday staples, increasingly on an international scale. Juvenile magazines proliferated as national distribution via rail became an option, and proved another popular choice; in 1870, there were 60 children's monthlies in America alone. Amid this clamoring for gift-worthy reading matter, even a homegrown bit of nonsense or narrative might catapult to far-reaching commercial success, as Edward Lear, Lewis Carroll, and A. A. Milne, among others, would all discover, to their initial astonishment.

The Blue Fairy Book
Andrew Lang, editor;
H. J. Ford and G. P. Jacomb Hood, illustrators
London and New York: Longmans, Green, and Co., 1889
5.8" x 9.6"
Kerlan Collection, Children's Literature Research Collections, University of Minnesota Libraries

Children's books from the 1860s often came with an embossed decoration on the front cover that enhanced their gift appeal and, in the days before illustrated dust jackets, also served as a form of point-of-purchase advertising. The editor of this handsomely decorated volume, Andrew Lang, was a prolific Scots poet, critic, historian, and folklorist who, following in the Grimms' footsteps, collected traditional tales he feared might otherwise be lost. Starting with *The Blue Fairy Book,* shown here, Lang published a series of 13 juvenile gift editions of such stories, each volume cleverly bound in and named for a different color of the rainbow.

The Yellow Fairy Book
Andrew Lang, editor;
H. J. Ford and G. P. Jacomb Hood, illustrators
London and New York: Longmans, Green, and Co., 1894
5.4" x 7.35"
Kerlan Collection, Children's Literature Research Collections, University of Minnesota Libraries

The Brown Fairy Book
Andrew Lang, editor;
H. J. Ford and G. P. Jacomb Hood, illustrators
London and New York: Longmans, Green, and Co., 1904
5.3" x 7.4"
Kerlan Collection, Children's Literature Research Collections, University of Minnesota Libraries

The Red Fairy Book
Andrew Lang, editor; Reisie Lonette, illustrator
New York: Looking Glass Library, 1960 (1890)
5.25" x 7.5"
Kerlan Collection, Children's Literature Research Collections, University of Minnesota Libraries

Off the Shelf: Giving and Getting Books 85

Japanese Fairy Tale, Princess Splendor
Tokyo: T. Hasegawa, 1880
5" x 6.75"
Kerlan Collection, Children's Literature Research Collections, University of Minnesota Libraries

In the decades following the arrival in Tokyo Bay of Commodore Perry's "Black Ships" and Japan's forced reopening to trade with the West, a thriving market developed for souvenir gift books like the one shown here. Specially printed on crepe paper and featuring colorful wood-block-printed art, sets of these fairy-tale volumes were offered in English, French, and German, in various formats, and at a range of prices.

Off the Shelf: Giving and Getting Books 87

A Book of Nonsense
Edward Lear
Pen and ink,
London: Frederick Warne and Company, 1875 (1846)
9.5" x 10.6"
Kerlan Collection, Children's Literature Research Collections, University of Minnesota Libraries

Born the twentieth of 22 children, Lear achieved early renown as an ornithological illustrator, publishing his first major work, *Illustrations of the Family of Psittacidae, or Parrots*, at the age of 19. He produced *A Book of Nonsense* on a lark—as a one-of-a-kind keepsake for the children of his patron, the Earl of Derby. Lear's rhymes and drawings proved to be a great hit with his young friends, and he soon yielded to the Earl's urgings to publish them all in a book. To safeguard his reputation, he did so under a pen name—the suitably fanciful "Derry Down Derry." Following the book's resounding success, he changed his mind and substituted his own name starting with the sixth edition.

88 Off the Shelf: Giving and Getting Books

There was an Old Man of the South, who had an immoderate mouth;
But in swallowing a dish that was quite full of Fish,
He was choked, that Old Man of the South.

There was an Old Man with a flute,—a "sarpint" ran into his boot!
But he played day and night, till the "sarpint" took flight,
And avoided that Man with a flute.

The Tale of Peter Rabbit
Beatrix Potter
1901, (First Issue)
4" x 5.35"
Kerlan Collection, Children's Literature Research Collections, University of Minnesota Libraries

Anxious to launch her career, Beatrix Potter first self-published *The Tale of Peter Rabbit* with black-and-white art. The following year, in response to strong Christmas-time demand, she arranged for commercial publication, this time with color illustrations.

Off the Shelf: Giving and Getting Books

The Tale of Peter Rabbit
Beatrix Potter
Frederick Warne, 1902
4.3" x 5.6"
Kerlan Collection, Children's Literature Research Collections, University of Minnesota Libraries

Dr. Kerlan's note tucked inside front cover of this copy of The Tale of Peter Rabbit:
(This copy is from the author's own library which accounts for its immaculate condition.
It has all the "points" of the 1st issue.
(a) Flowered end pages
(b) 31 colored plates
(c) Edward Evans name on reverse of title
(d) No copy right notice
(e) 98 pages
The cloth issue is much rarer than the one in board, as fewer were done.)

Off the Shelf: Giving and Getting Books

Winnie-the-Pooh (top L)
A. A. Milne; E. H. Shepard, illustrator
London: Methuen & Co. Ltd., 1926
5" x 7.5"
Kerlan Collection, Children's Literature Research Collections, University of Minnesota Libraries

Winnie-the-Pooh (bottom L)
A. A. Milne; E. H. Shepard, illustrator
New York: E.P. Dutton, 1935
5.4" x 7.5"
Kerlan Collection, Children's Literature Research Collections, University of Minnesota Libraries

Winnie Ille Pu (bottom R)
A. A. Milne; Alexander Lenard, translator
Stuttgardiae: S. H. Goverts, 1962
5" x 7"
Kerlan Collection, Children's Literature Research Collections, University of Minnesota Libraries

The storybook character Winnie-the-Pooh began life as a store-bought stuffed bear named Edward. Its owner, Christopher Milne, was the son of the well-known London playwright and novelist A. A. Milne, who took his son as the model for Christopher Robin and assigned roles to other household toys—Eeyore, Piglet, Kanga, and Tigger.

Off the Shelf: Giving and Getting Books

The Pooh Dolls
Photo courtesy of The New York Public Library
and used with permission

The Pooh dolls have lived at The New York Public Library since 1987, a gift of Milne's American publisher.

THE POKY LITTLE PUPPY

The Poky Little Puppy
Janette Sebring Lowrey; Gustaf Tenggren, illustrator
New York: Western/Simon & Schuster, 1942
Cover art, watercolor and gouache on paper, 0.4" x 14.5" (opp)
Four puppies, watercolor and gouache on paper, 9.5" x 6" (top)
Poky Puppy, water color and gouache on paper, 10" x 16.5" (bottom)
Interior spread, watercolor and gouache on paper,
17.5" x 11" (next page)
Kerlan Collection, Children's Literature Research Collections, University of Minnesota Libraries

In the fall of 1942, the first 12 Little Golden Books, including *The Poky Little Puppy*, went on sale for 25 cents each and revolutionized children's book publishing in America. Picture books had until then typically retailed for $1.50 and could rarely be purchased outside major cities. The new venture—a partnership between a state-of-the-art printing company and an upstart publisher with mass market savvy—rewrote the rules. Sold in five-and-dimes, drugstores, and, later, supermarkets, Little Golden Books were the illustrated gift books everybody could afford. *The Poky Little Puppy* proved to be a special favorite from the start and is thought to be the best-selling picture book of all time.

p.6-7

"Write" Off the Assembly Line

Writer-entrepreneur Edward Stratemeyer was the singular mastermind behind an impressive array of American juvenile fiction series, generating a number of all-time best sellers. Between 1910 and 1930, his Stratemeyer Syndicate employed an army of ghostwriters, editors, and stenographers dedicated to turning out "slam-bang," 50-cent tales of the youthful adventures of the Rover Boys, Tom Swift, the Hardy Boys, the Bobbsey Twins, and Nancy Drew.

Stratemeyer amassed a fortune by marrying the fast-paced, character-driven storytelling of his mentor, Horatio Alger, Jr., with the assembly-line production techniques of his other lifelong hero, Henry Ford. (One Syndicate veteran referred to the exacting, formula-based writing process as "fitting the pipes.") High-minded librarians shunned the Syndicate's standard-issue chapter books as subliterary and "cheap," but a 1926 American Library Association survey of 36,000 young people told a different story: fully 98% of respondents placed a Stratemeyer title at the top of their list of all-time favorite books.

Ragged Dick; or,
Street Life in New York with the Bootblacks
Horatio Alger, Jr.
Philadelphia: Henry T. Coates, 1895 (1868)
5.6" x 7.7"
Kerlan Collection, Children's Literature Research Collections, University of Minnesota Libraries

Alger sealed his reputation in 1868 with this, his fourth juvenile novel, an aspirational tale of an honest New York City bootblack's rise from poverty to respectability. Alger's vast output of formula fiction for boys defined the American dream for generations of young people, among them a New Jersey tobacconist's son named Edward Stratemeyer, who enthusiastically plowed through Alger's storybooks as a youth and went on to become the author's ghostwriter and unofficial successor.

234 RAGGED DICK; OR,

Now Dick was an expert swimmer. It was an accomplishment which he had possessed for years, and he no sooner saw the boy fall than he resolved to rescue him. His determination was formed before he heard the liberal offer made by the boy's father. Indeed, I must do Dick the justice to say that, in the excitement of the moment, he did not hear it at all, nor would it have stimulated the alacrity with which he sprang to the rescue of the little boy.

Little Johnny had already risen once, and gone under for the second time, when our hero plunged in. He was obliged to strike out for the boy, and this took time. He reached him none too soon. Just as he was sinking for the third and last time, he caught him by the jacket. Dick was stout and strong, but Johnny clung to him so tightly, that it was with great difficulty he was able to sustain himself

"Put your arms round my neck," said Dick.

The little boy mechanically obeyed, and clung with a grasp strengthened by his terror. In this position Dick could bear his weight better. But the ferry-boat was receding fast. It was quite impossible to reach it. The father, his face pale with terror and

DICK SAVING JOHNNY.

Off the Shelf: Giving and Getting Books 99

Edward Stratemeyer in his home office in Newark, New Jersey
Gelatin silver print, ca. 1905
Manuscripts and Archives Division,
The New York Public Library

As a teenager raised in middle-class comfort in Elizabeth, New Jersey, Edward Stratemeyer owned a fully functioning miniature printing press. He used it to entertain and impress his friends, publishing broadsides and fledgling stabs at fiction, among them a bombastic tale titled "Revenge! Or, The Newsboy's Adventure." Stratemeyer's pragmatic father was not amused, and warned him there was no money in writing.

This self-assured portrait was taken at about the time of the founding of the Stratemeyer Syndicate, and was perhaps meant to memorialize that milestone event. To staff his "fiction factory," Stratemeyer turned primarily to newspapermen for their proven ability to hammer out acceptable copy on deadline. He assigned his writers to a particular series and furnished them with a detailed one-or-two-page outline for each successive volume. A tautly worded synopsis of the previous installment and cliffhanger chapter endings were among the many requirements that prompted one veteran Syndicate ghostwriter to characterize his job as "fitting the pipes."

Opposite page: All covers are from the Hess Collection, University of Minnesota Libraries
(from the top, L to R)

The Bobbsey Twins
Laura Lee Hope
New York: Grosset and Dunlap, 1904

The Rover Boys In the Air
Arthur M. Winfield
New York: Grosset and Dunlap, 1912

Shorthand Tom, The Reporter
Edward Stratemeyer; A. B. Shute, illustrator
Boston: Lee & Shepard, 1903

The Moving Picture Girls
Laura Lee Hope
New York: Grosset and Dunlap, 1914

The Hardy Boys, The Tower Treasure
Franklin W. Dixon
New York: Grosset and Dunlap, 1927

The Motion Picture Chums, First Venture
Victor Appleton
New York: Grosset and Dunlap, 1913

Nancy Drew Mystery Stories, The Hidden Staircase
Carolyn Keene
New York: Grosset and Dunlap, 1930

Treasure Seekers of the Andes
Edward Stratemeyer
Boston: Lothrop, Lee & Shepard, 1907

Tom Swift and the Electronic Hydrolung
Victor Appleton II; Charles Brey, illustrator
New York: Grosset & Dunlap, 1961

Off the Shelf: Giving and Getting Books 101

A DISASTROUS FLIGHT　　45

his legs became tangled in some things in the bottom of the car, and he could not extricate himself.

"I—I can't jump!" he shouted back.

"Shut off the motor!" yelled his machinist, pushing his way through the crowd.

"I can't do that either. Something's the matter with it! It won't stop!"

The *Firefly* was approaching nearer and nearer to the lemonade stand. The proprietor was frantically jumping up and down in front of his possessions, as if he could thus ward off the attack of the airship.

"Stop! Stop, I tell you!" he shouted, shaking his fist at the *Firefly*, which every second was coming nearer.

"Look out!" yelled the crowd. "She's going to hit!"

And hit she did a moment later. At the last moment Noddy managed to leap, and he did so only just in time, for there was a resounding crash, a rending and splintering of wood. The lemonade and candy stand seemed to crumple up. One side gave way to admit the pointed prow of the *Firefly*, then the stand seemed to swallow up the airship.

All at once there flew in all directions packages of candy, popcorn and boxes of other confections.

"THE AEROPLANE WAS NOW WITHIN TEN FEET OF THE PLATFORM."
—Page 66.

Motor Boys
Clarence Young; Charles Nuttall, illustrator
New York: Cupples & Leon, 1910
5.6" x 7.7"
Hess Collection, University of Minnesota Libraries

**Der Schatz im Silbersee
(The Treasure of Silver Lake)**
Karl May
Bamberg: Karl May Verlag, 1952 (1891)
4.75" x 7"
Kerlan Collection, Children's Literature Research Collections,
University of Minnesota Libraries

Karl May was late 19th century Germany's Edward Stratemeyer—a human writing machine with a preternatural gift for generating teen adventure fiction. His favorite subject was the American West, a place he never visited. In this, his most famous storybook, a salt-of-the-earth frontiersman, Old Firehand, and his trusted Apache Indian friend, Winnetou, join forces to prevent a callous murderer from getting his hands on hidden treasure. The wide-open spaces, fast-paced, often violent action, and clearcut morality of May's fiction had immense appeal for Europe's disillusioned youth in the days of fading old world imperial glory.

Off the Shelf: Giving and Getting Books

No Dogs or Children Allowed

"No dogs or children allowed" was the curmudgeonly mantra of many an American public library until the turn of the last century, when social reformers won dramatic expansions of juvenile rights. Thereafter, Children's Rooms staffed by trained specialists became the new norm. A revolution in free public access to children's books had begun.

As the publishing industry's hometown library, The New York Public Library led the charge. With missionary fervor for battling commercialism and enriching young lives, the NYPL's children's librarian Anne Carroll Moore issued annual Best Books lists, published her fiery opinions in the *New York Herald-Tribune,* cofounded Children's Book Week, and helped launch the Newbery and Caldecott Medals. She hosted story hours, exhibited illustrators' artwork, purchased foreign-language children's books, and hired a multiracial, multilingual staff. Moore had her critical blind spots, most famously her abhorrence of E. B. White's *Stuart Little,* but her innovative practices—and protégés—swept America, and children's librarians from Stockholm to Tokyo were soon modeling their work on hers.

Anne Carroll Moore at her office in The New York Public Library
Gelatin silver print, ca. 1906, (opp, top, L)
Manuscripts and Archives Division,
The New York Public Library

Anne Carroll Moore joined The New York Public Library in 1906, taking up temporary "wilderness" quarters in the Muhlenberg branch, on West 23rd Street, while planning and construction of the new central building proceeded. One of her first tasks was to purge the motley collection of subliterary dime novels and series fiction she had inherited. Moore relished the chance to set new standards for juvenile literature from her highly visible post in the capital city of American publishing. "I was having the time of my life," she later recalled, in a job that "knock[ed] the spots out of any other like position in the country."

Hamilton Fish Branch. Private care of public property—covering their books
Photographer Lewis Hine
Manuscripts and Archives Division, The New York Public Library

Nicholas. His map.
Pictorial map of New York. Drawn by Jay Van Everen for *Nicholas, a Manhattan Christmas Story.*
by Anne Carroll Moore.
G.P. Putnam Sons. Marketing materials 1923.

Off the Shelf: Giving and Getting Books 105

MEETING BEATRIX POTTER

A die-hard Anglophile, Anne Carroll Moore wished, naturally, to meet the creator of Peter Rabbit on her first trip to England, in the spring of 1921. Beatrix Potter had left London years earlier to live reclusively as a Lake District sheep farmer. Might she agree to receive an American admirer, Moore asked her British editor? "I can only wish you luck," replied Fruing Warne, gloomily. Moore finessed an invitation and was ambling up to the artist's cottage when, suddenly, "Potter came 'out of the hay' to greet me . . . her bright blue eyes sparkl[ing] with merriment." Potter knew of Moore's pioneering efforts to promote children's literature and thanked her for championing it as an art form—a case seldom argued in Britain. As a parting gesture that sealed their friendship, Potter opened her portfolio and invited her discerning guest to "choose any one piece you think your children in New York would like."

Beatrix Potter
Kerlan Collection, Children's Literature Research Collections, University of Minnesota Libraries

The Tale of Peter Rabbit
Beatrix Potter
process art, 1928, pencil on paper, 6" x 3.8" (opp, top)
pencil on paper, 3" x 4" (opp, bottom)
Kerlan Collection, Children's Literature Research Collections, University of Minnesota Libraries

Anne Carroll Moore revered Potter as a touchstone artist for American illustrators to emulate. Potter in turn felt gratitude for the seriousness with which Moore championed the art form to which she had devoted her life, and which few in her own country seemed to hold in the same high regard.

My pony — whose real name was Dolly loved water. When ever she and I crossed a stream, Dolly stopped the pony-cart and had a good splash. She never actually lay down and rolled, but I was always expecting her to do so. Beatrix Potter

The Fairy Caravan
Beatrix Potter
Philadelphia: David McKay and Company, 1929
6.75" x 8.7"
Kerlan Collection, Children's Literature Research Collections, University of Minnesota Libraries

The few books published in her later years were primarily based on ideas conceived in the early part of her life and were not considered critical successes. *The Fairy Caravan* is notable in that it is more autobiographical than her previous works, but, wrote Marcus Crouch in *Three Bodley Head Monographs*, "It is nevertheless a sad book, as every work of fading genius must be sad." Indeed, Potter herself recognized its weakness and only allowed a limited printing in the United States and England.

The Fairy Caravan
Beatrix Potter
process art, 1929
pencil and ink on paper, 6.3" x 3.9" (top)
pencil and ink on paper, 6.5" x 3.8" (opp)
Kerlan Collection, Children's Literature Research Collections, University of Minnesota Libraries

Beatrix Potter
1929

CHAPTER VIII

PADDY PIG was an important member of the circus company. He played several parts—the Learned Pig that could read, in spectacles; the Irish Pig that could dance a jig; and the Clown in spotty calico. And he played the Pigmy Elephant. It was done in this way. He was the right elephant colour— shiny black, and he had the proper flap ears, and small eyes. Of course, his nose was not nearly long enough and he had no tusks. So tusks were shaped from white peeled sticks out of the hedge, and a black stocking was stuffed

Andy and the Lion
James Daugherty
New York: The Viking Press, 1946 (1938)
8" x 11"
Kerlan Collection, Children's Literature Research Collections, University of Minnesota Libraries

James Daugherty began his art career as a Synchronist abstractionist—a painter under the spell of Cézanne, Matisse, and Delaunay. By the mid-1920s, however, he had reinvented himself as a muralist and illustrator specializing in American subjects. In this, his first children's picture book, Daugherty reset the legend of Androcles and the Lion in a Norman Rockwell–esque American small town. A local library figures prominently in the narrative, and Daugherty, who was a favorite speaker at The New York Public Library's Central Children's Room, dedicated the book to "Lady Astor and Lord Lenox, the Library Lions," who flank the Fifth Avenue entrance.

Henry - Fisherman. A Story of the Virgin Islands
Marcia Brown
New York: Charles Scribner's Sons, 1949
10.25" x 8"
Kerlan Collection, Children's Literature Research Collections, University of Minnesota Libraries

Marcia Brown dreamed from childhood of becoming an illustrator. Brown moved from upstate New York to Manhattan in the early 1940s, where she worked in The New York Public Library's Central Children's Room while taking classes at the Art Students League. Brown went on to have a fabled illustration career, garnering three Caldecott Medals and six Caldecott Honors.

About *Henry - Fisherman*, her second Honor book, Brown recalled, "I loaned the book's original illustrations [for a library exhibition]. They proved so popular with the public [that] they remained on view for two years. . . . I was glad [because] in the early fifties there were few books showing black children." (In an email to L.S.M. 2013)

East of the Sun and West of the Moon, Twenty-One Norwegian Folk Tales
Ingri and Edgar Parin d'Aulaire
Eau Claire, WI: E.M. Hale and Company, 1951 (1938)
Originally published by New York: Viking Press
6.5" x10"
Kerlan Collection, Children's Literature Research Collections, University of Minnesota Libraries

The d'Aulaires—European émigré artists who arrived in New York around 1930—credited Anne Carroll Moore with having coaxed them into making a career of children's-book writing and illustration. The couple, who always worked as a team, were awarded the 1940 Caldecott Medal for their picture book biography, *Abraham Lincoln*.

Off the Shelf: Giving and Getting Books 111

The Poppy Seed Cakes
Margery Clark; Miska and Maud Petersham, illustrators
Garden City, N.Y.: Doubleday, 1924
6.5" x 8"
Kerlan Collection, Children's Literature Research Collections, University of Minnesota Libraries

Not all books with an international flavor had to be imported. In some juvenile books published in the United States from the 1920s through 1940s, European émigré artists opted to share a taste of their Old World traditions with the children of their newly adopted home. Miska Petersham (in collaboration with his Vermont-born wife, Maud) created the art for this widely praised volume in a style reminiscent of the brightly decorative folk art of his native Hungary.

shek was swinging backward and forward and backward and forward on the dark green gate. The chickens and the cat had long before run out into the road.

"How do you do, Andrewshek?" said the white goat.

"How do you do, White Goat?" said Andrewshek. "Where are you going?"

"HOW DO YOU DO, ANDREWSHEK?"

Off the Shelf: Giving and Getting Books

Albanian Wonder Tales
Post Wheeler; Miska and Maud Petersham, illustrators
Garden City, New York: Junior Literary Guild, 1936
6" x 9"
Kerlan Collection, Children's Literature Research Collections,
University of Minnesota Libraries

Albanian Wonder Tales
process art: ink and tempera on paper
7" x 6.75"
Kerlan Collection, Children's Literature Research Collections,
University of Minnesota Libraries

Off the Shelf: Giving and Getting Books 113

Storyteller en la Biblioteca: Pura Belpré

In 1921, a Puerto Rican teenager traveled to New York City with plans to stay just long enough to attend her sister's wedding. Instead, Pura Belpré remained in the city for the next 61 years, becoming The New York Public Library's first Puerto Rican librarian and one of the city's most eloquent champions of Latino culture. Belpré worked primarily at the NYPL's 115th Street branch, amid southwest Harlem's burgeoning Puerto Rican population. To attract local families, she introduced bilingual story hours and puppet shows and hosted celebrations of El Día de Reyes (Three Kings' Day). She called on schools and reached out to community groups in countless ways.

Disappointed by the dearth of children's books on Latino themes, Belpré wrote her own, starting with the now-classic *Pérez and Martina*. Since 1996, the American Library Association and its affiliate REFORMA have issued an annual award named in Belpré's honor to recognize outstanding Latino writers and illustrators.

115th Street, storytelling group with Miss Pura Belpré
Gelatin silver print, ca. 1940s
Manuscripts and Archives Division,
The New York Public Library

Pérez y Martina: Un cuento folklórico puertorriqueño (Pérez and Martina: A Puerto Rican Folktale)
Pura Belpré; Carlos Sánchez, illustrator
New York: F. Warne, 1961 (1932)
10" x 8.3"
Kerlan Collection, Children's Literature Research Collections,
University of Minnesota Libraries

In 1926, Pura Belpré enrolled in the Library School of The New York Public Library. For "The Art of Storytelling" course, she was required to compose a short narrative. The story she submitted, based on a folktale remembered from childhood, became her first picture book, shown here. Martina, a beguiling and elaborately coifed cockroach, sits on her front porch as one suitor after another comes calling. In the end, refinement wins out as Pérez, the courtly mouse, triumphs over his louder, showier rivals.

Off the Shelf: Giving and Getting Books 115

Librarian Augusta Baker showing a copy of Ellen Tarry's *Janie Belle* to a young girl at the library
Schomburg Center for Research in Black Culture, Photographs and Prints Division, The New York Public Library, New York Public Library Digital Collections, 1941

Augusta Baker was a children's librarian who made history at every stage of her long and eventful career. As a Harlem branch librarian during the 1930s and 1940s, she spoke out vigorously in favor of more children's books for and about young people of color. She later led the Library's famed storytelling training program and became the first African American to head a division of The New York Public Library—youth services.

My Dog Rinty is the work of Ellen Tarry, a Harlem Renaissance writer who first ventured into children's literature with prompting from Baker and the Bank Street School's Lucy Sprague Mitchell.

My Dog Rinty
Ellen Tarry and Marie Hall Ets; Alexander and Alexandra Alland, photographers
New York: Viking, 1946
7.8" x 9.3"
Kerlan Collection, Children's Literature Research Collections, University of Minnesota Libraries

116 Off the Shelf: Giving and Getting Books

Higgledy Piggedy Room
Elizabeth Ryan; Kurt Werth, illustrator
New York: Shady Hill Press, 1948
The Black Experience in Children's Books: Selections from Augusta Baker's Bibliographies
Schomburg Center for Research in Black Culture, Jean Blackwell Hutson Research and Reference Division, The New York Public Library. "Higgledy-Piggledy Room" The New York Public Library Digital Collections. 1948.

Fun with David
Research Council of the Great Cities Program for School Improvement (Editor), Ives, Ruth (Illustrator)
Chicago: Follett Publishers, 1962
The Black Experience in Children's Books: Selections from Augusta Baker's Bibliographies
Schomburg Center for Research in Black Culture, Jean Blackwell Hutson Research and Reference Division, The New York Public Library. The New York Public Library Digital Collections. 1962.

Nappy Has A New Friend
Inez Hogan
New York: E.P. Dutton, 1947
The Black Experience in Children's Books: Selections from Augusta Baker's Bibliographies
Schomburg Center for Research in Black Culture, Jean Blackwell Hutson Research and Reference Division, The New York Public Library. "Nappy Has a New Friend" The New York Public Library Digital Collections. 1947.

Off the Shelf: Giving and Getting Books

The Tale of Despereaux
Kate DiCamillo; Timothy Basil Ering, illustrator
Somerville, MA: Candlewick Press, 2003
6.5" x 8.8"
Reproduced by permission of the publisher,
Candlewick Press, Somerville, MA.

Newbery Medal
René Paul Chambellan, designer
Bronze, 1921
Newbery Medal (above) awarded to Carol Ryrie Brink for her novel, *Caddie Woodlawn*, 1936.
Caldecott Medal (opposite) awarded to Marie Hall Ets for her book, *Nine Days to Christmas*, 1960.
Kerlan Collection, Children's Literature Research Collections, University of Minnesota Libraries

Named for John Newbery, the pioneering 18th-century English publisher of juvenile literature, the Newbery Medal was established by the American Library Association in 1921 as children's literature's counterpart to the Pulitzer Prize. A companion award for illustration, the Caldecott Medal, was first conferred in 1938.

Finding Winnie: The True Story of the World's Most Famous Bear
Lindsay Mattick; Sophie Blackall, illustrator
New York: Little, Brown Books for Young Readers, 2015
10.4" x 10.2"
Kerlan Collection, Children's Literature Research Collections,
University of Minnesota Libraries

Off the Shelf: Giving and Getting Books

Book Week

In the summer of 1919, Anne Carroll Moore and a handful of others met at The New York Public Library to lay the groundwork for Children's Book Week, an annual national observance aimed at encouraging parents to read to their children and keep high-quality books for them at home. That November, the first Book Week was celebrated all across America with talks, teas, lectures, parades, and other public events, and with a specially commissioned poster on display in schools, bookshops, and libraries. Jessie Willcox Smith, a noted book illustrator and *Good Housekeeping*'s regular cover artist, created the first two Book Week poster designs. The roster of her successors—N. C. Wyeth, Ellen Raskin, Tomi Ungerer, and William Steig, to name a few—is a who's who of American illustration.

The Story of "Book Week,"
The Elementary English Review
Frederic Melcher, editor of *The Publishers' Weekly*, 1930
8.5" x 11.5"
Kerlan Collection, Children's Literature Research Collections, University of Minnesota Libraries

Book Week Poster, 1945
17" x 21"
Kerlan Collection, Children's Literature Research Collections, University of Minnesota Libraries

Following pages:
Book Week Poster, 1969
18" x 23"
Emily Arnold McCully
Kerlan Collection, Children's Literature Research Collections, University of Minnesota Libraries

International Children's Book Day Poster
Maurice Sendak
11.5" x 15.75"
Kerlan Collection, Children's Literature Research Collections, University of Minnesota Libraries

UNITED THROUGH BOOKS

BOOK WEEK
NOVEMBER 11-17 1945

Hans Christian Andersen
April 2, 1805 — August 4, 1875

INTERNATIONAL CHILDREN'S BOOK DAY

© The Children's Book Council, Inc.

Lights Out: Reading Under the Covers

"What is there about Comics that makes children like them so well?" A battle-scarred Ohio school teacher posed this question in 1943, in the pages of *Library Journal.* Mid-20th-century librarians and educators bemoaned comic books and their garishly printed, sensational tales of crime-fighting superheroes as a threat to their own mission as cultural standard-bearers. With a million fans a month reading *Superman* alone, the action-packed, 10-cent magazines had indeed connected with America's youth in a big way. Not only could children purchase the latest installments with their own pocket money, but those whose parents disapproved of comics could double their fun by reading them in secret.

Virginia Lee Burton—a future Caldecott winner—contrived, in vain, an elegant, comics-style picture book as an upmarket alternative. Others looked to *Curious George* for a cure. But it took a psychiatrist's postwar best seller, and the Senate hearing it inspired, to finally slam the brakes on the comics craze, leaving behind a largely eviscerated industry with one unanticipated bright spot: the deadpan, anarchic satire of *Mad* magazine.

Superman 1, no. 79
November–December 1952
7″ x 10″
General Research Division,
The New York Public Library

DC Comics' *Superman*, the first comic-book superhero to captivate a vast national audience, drew harsh words from psychiatrist Fredric Wertham. In *Seduction of the Innocent*, Wertham warned of the "Superman Complex"—the arousal of fantasies of "sadistic joy in seeing other people punished over and over again while you yourself remain immune." Following the establishment in 1954 of the Comics Code Authority, *Superman*'s creators reinvented the Man of Steel for less hospitable times. As exemplified here, his adventures were now apt to be elaborately science fiction–based, and to involve exotic extraterrestrial travel as well as supervillains who were all too obviously unreal.

Off the Shelf: Giving and Getting Books

Curious George
H. A. Rey
Boston: Houghton Mifflin, 1941
8.75" x 10.5"
Kerlan Collection, Children's Literature Research Collections, University of Minnesota Libraries

H. A. Rey and his wife, Margret, famously slipped out of Nazi-occupied France with the artwork and manuscript for this jaunty picture book strapped to their bicycles. When Houghton Mifflin published it the following fall, critics praised *Curious George* for its "clear, bright colors, its simplicity that eliminates confusing details and the zestful activity of its hero"—just the ticket, librarians hoped, for giving comic books a run for their money.

Curious George
process art: pencil, watercolor, ink on paper
H. A. and Margret Rey Papers,
de Grummond Children's Literature Collection,
University of Southern Mississippi Libraries

Off the Shelf: Giving and Getting Books 125

**Calico the Wonder Horse or
The Saga of Stewy Slinker**
Virginia Lee Burton
Boston: Houghton Mifflin, 1941
8.75" x 5.7"
Kerlan Collection, Children's Literature Research Collections,
University of Minnesota Libraries

Appearing together with *Curious George* on Houghton Mifflin's fall 1941 list was this forthright attempt at a high-quality alternative to the comics. Virginia Lee Burton, much admired by librarians for *Mike Mulligan and His Steam Shovel*, had spent a year of intensive experimentation before creating this "symphony in comics [set] way out West in Cactus County." By then, the comic-book craze had invaded Burton's own home, prompting the artist to consider why such "lurid tales" so enthralled children like her nine-year-old. Burton's findings had all but made a convert of her: "These books . . . satisfy a natural craving for excitement . . . action . . . drama," she had found. They offered a "hero to worship and an escape to thrilling adventure that is wanted by any normal child."

**Calico the Wonder Horse or
The Saga of Stewy Slinker**
Virginia Lee Burton
Boston: Houghton Mifflin, 1941
8.75" x 5.7"
Kerlan Collection, Children's Literature Research Collections, University of Minnesota Libraries
(opp, bottom) Interior spread
(opp, middle) end papers, thumbnail sketches
Cover of Second Edition
Calico the Wonder Horse or the Saga of Stewy Stinker.
Cambridge, Mass: Riverside Press 1950
(opp, top) Cloth Cover

126 Off the Shelf: Giving and Getting Books

Off the Shelf: Giving and Getting Books 127

Justice League of America no. 26
1964, March
7" x 10"
Borger Comic Collection, University of Minnesota Libraries

Introduced in September 1963 by Stan Lee and Jack Kirby, *The Avengers* represented Marvel Comics' fullcourt-press response to DC Comics' ground-shaking *Justice League*, a series that had debuted three years earlier. Both rivals headlined multiple superheroes from their respective publishers' quivers of licensed characters. Early on, *The Avengers* further distinguished itself by coming up with a memorable call to arms—"Avengers Assemble!"—and by promising its readers glorious confrontations with "the foes that no single superhero can withstand."

The Avengers, Kang the Conqueror
1964, September
7" x 10"
Borger Comic Collection, University of Minnesota Libraries

Amazing Spider-man: Wakanda Forever
Marvel 1, 2018
6.6" x 10"
Borger Comic Collection, University of Minnesota Libraries

128 Off the Shelf: Giving and Getting Books

MAD Magazine
Issue No. 1
New York: EC Comics, October 1952
National Archives

MAD Magazine
Mad 1, No. 56
New York: EC Comics, July 1960
Collection of Leonard S. Marcus

In 2010, veteran *MAD* contributor Al Jaffee told a reporter, "MAD was designed to corrupt the minds of children. And from what I'm gathering from the minds of people all over, we succeeded." Originally published in comic book format by EC Comics, the company whose blood-and-guts *Tales from the Crypt* became a lightning rod for critics like Fredric Wertham, MAD later reformatted itself as a magazine, thereby escaping the Comics Code Authority's scrutiny. From the start, MAD lampooned countless aspects of American life, from television sitcoms and advertising jingles to psychoanalysis and presidential politics, as seen in this issue dating from the 1960 Democratic primary season.

Off the Shelf: Giving and Getting Books

Seduction of the Innocent
Fredric Wertham
New York: Rinehart & Co., Inc., 1954
5.5" x 8.25"
Rodney A Briggs Library, University of Minnesota Morris

This best seller by the German-American psychiatrist Fredric Wertham crystallized the case against comic-book violence as a catalyst to juvenile delinquency and a host of related problems. Wertham authoritatively declared, "It is our clinical judgment, in all kinds of behavior disorders and personality difficulties of children, that comic-books do play a part." The author restated his argument at a 1954 hearing of the United States Senate Subcommittee on Juvenile Delinquency, a watershed inquiry to which industry executives were also called to testify. Fearing impending federal action, publishers preemptively instituted the self-censoring Comics Code Authority, a move that mollified critics but also had a chilling effect on many of the era's boldest comics creators.

The Ten-Cent Plague: The Great Comic-Book Scare and How It Changed America
David Hajdu
New York: Picador, 2009
5.5" x 8.2"
Kerlan Collection, Children's Literature Research Collections, University of Minnesota Libraries

130 Off the Shelf: Giving and Getting Books

CENSORSHIP

A NOVEL BY JUDY BLUME
ARE YOU THERE GOD? IT'S ME, MARGARET.

Raising a Ruckus

Children's books have often served as lightning rods for controversy, with topics considered taboo—death, race, and sex chief among them—and notions of child-appropriateness triggering sharp debate and vigorous efforts to limit or bar access to certain books. While acts of censorship are often driven by overt political or cultural agendas, other, more ambiguous cases blur the line between blatant suppression and well-intentioned editorial—or parental—judgment.

In the United States, censorship has typically been instigated by self-appointed gatekeepers, not centralized governmental authorities. Cold War–era authors Garth Williams, Madeleine L'Engle, Maurice Sendak, and Judy Blume saw their popular books routinely challenged, primarily by fundamentalist religious groups. Nearly a century before, Mark Twain had divined an upside to such pious literary witch-hunts. When informed that the Concord, Massachusetts, public library had "expelled" *Huckleberry Finn* from its shelves, deeming it "trash," Twain crowed to his publisher, "That will sell 25,000 copies for us sure."

Are You There God? It's Me, Margaret. (prev. page)
Judy Blume
New York: Dell Pub. Co., 1970
5.6" x 8.3"
Kerlan Collection, Children's Literature Research Collections, University of Minnesota Libraries

During the 1980s, when the overall number of challenges to books for children and teens is estimated to have quadrupled, Judy Blume became the American author for young people whose work was most frequently banned. High on the list of Blume's controversial novels was this one, which dealt candidly with the onset of puberty in girls and an 11-year-old's questioning attitude toward organized religion.
Are You There God? It's Me, Margaret. was first published in 1970 by the small, independent Bradbury Press, based in Scarsdale, New York. It was two years later, however, when the Dell Yearling paperback edition appeared, that young people who could afford to buy copies with their own money made it a best seller and Blume a cultural force to be reckoned with.

Pippi Långstrump (Pippi Longstocking)
Astrid Lindgren; Ingrid Vang Nyman, illustrator
Stockholm: Rabén & Sjögren, 1945
4.25" x 6.5"
Kerlan Collection, Children's Literature Research Collections,
University of Minnesota Libraries

Astrid Lindgren's tale about the free-spirited, self-regulating Pippi Longstocking—a natural child par excellence—was a popular success, though it drew sharp criticism from leading Swedish educator John Landquist, who condemned it for planting unrealistic ideas in children's heads. Lindgren's French publisher concurred to a point, changing the horse Pippi lifts in the air to a (somewhat) more plausible pony—a move that later prompted a pro-Pippi backlash. The American editor ultimately deferred to Lindgren after first protesting the novel's excessive brashness. Born to trouble, Pippi would withstand similar challenges from Norway to Iran, as well as a noir-ish makeover as Lisbeth Salander, the shortfused, lonewolf hacker of Stieg Larsson's *The Girl with the Dragon Tattoo*.

A Wrinkle in Time
Madeleine L'Engle
New York: Farrar, Straus and Giroux, 1962
5.75" x 8.37"
Kerlan Collection, Children's Literature Research Collections,
University of Minnesota Libraries

As president of the Authors Guild from 1985 to 1986, Madeleine L'Engle vigorously defended writers' freedom of expression, having by then experienced significant challenges to her own books. Early attacks labeled *A Wrinkle in Time*—the 1963 Newbery Medal winner—"too Christian." Was not young Charles Wallace a Christ figure, and the three eccentric lady characters angels? By the 1980s, the book's chief opponents were no longer secularists but Christian fundamentalists, who condemned *A Wrinkle in Time* for being Christian in the wrong way. L'Engle had equated Jesus with Leonardo and Einstein, and the ladies were not angels but witches.

Off the Shelf: Giving and Getting Books

Adventures of Huckleberry Finn (Tom Sawyer's Comrade)
Mark Twain [Samuel Clemens]; Edward W. Kemble, illustrator
London: Chatto & Windus, 1884
7" x 9"

Kerlan Collection, Children's Literature Research Collections, University of Minnesota Libraries

Mark Twain came to prominence as a writer in the decades after the Civil War, when pride in America's emerging national literature was on the rise and a genteel Victorian-era aesthetic prevailed. Against this backdrop, more than a few of the nation's all-powerful East Coast critics regarded Twain as a frontier diamond in the rough, and his hearty embrace of vernacular English as an appalling setback. Early bans of *Huckleberry Finn* arose from objections to the supposed vulgarity of the author's prose and to scenes such as the one in which Jim and Huck are naked together on their raft.

More recently, after decades as required reading in schools, Twain's novel has stirred renewed controversy over the author's vernacular use of the pejorative "nigger," prompting at least one publisher to issue a school edition completely purged of the word.

134 Off the Shelf: Giving and Getting Books

Segregationists Protest
Alabama Restricts Children's Book In Which White, Black Rabbits Wed

NEW YORK, May 21 (UPI)— A children's book called "The Rabbits' Wedding" has been banned from the open shelves of Alabama public libraries because of segregationist criticism that the book has a white rabbit marry a black one.

Harper & Brothers, which published the volume by Garth Williams, said the book was banned because some persons objected to its "possible anti-segregation motives."

Emily Wheelock Reed, director of the Alabama Public Library Service Division, said that the book had not been banned.

"That would not be morally right," she said. "We have put it on the reserve shelf where the public can get it by request only.

"We have had difficulty with the book. We have heard rumblings since last fall but we have not lost our integrity. I am interested in seeing the library division grow and expand and we had to make a choice because of the aroused feelings to stop peddling the book."

She said there had been no direct pressure on the library.

"However, the Montgomery Home News (publication of the Montgomery chapter of the Citizens Councils) came out with a story about the book promoting integration," she said. "Then we put it on the reserve shelf. Personally, I like the book."

The book came under fire after the Home News published an article detailing the story under the headline, "What's Good Enough for Rabbits Should Do For Mere Humans."

Williams said in a statement that the book "has no political significance."

"I was completely unaware that animals with white fur ... were considered blood relations of white human beings," he said.

Williams said the book "was not written for adults who will not understand it because it is only about a soft furry love and has no hidden messages of hate."

The book describes the rabbits' moonlight wedding attended by all the other animals of the forest.

Burn Rabbit Book, Urges Legislator

MONTGOMERY, Ala., May 22 (UPI)—An Alabama state legislator said today a children's book depicting the marriage of a white girl rabbit and a black boy rabbit should be burned.

State Sen. E. O. Eddins of Demopolis, a leader of segregation forces in the Legislature, said the picture book should be "taken off the shelves and burned" even though it is intended for pre-school-age children.

"There are many other books of the same nature and others that are Communistic which should be burned as well," Eddins said.

The Rabbits' Wedding
Garth Williams
New York: Harper & Brothers, 1958
9.75" x 12.5"
Kerlan Collection, Children's Literature Research Collections,
University of Minnesota Libraries

Best known as the illustrator of children's books by E. B. White, Laura Ingalls Wilder, and Margaret Wise Brown, Garth Williams occasionally wrote his own material. This picture book about the marriage between a white and a black rabbit caused a furor, especially in Alabama. *The Montgomery Home News*, a local publication of the segregationist White Citizens Coucil, condemned Williams' fable for its seeming endorsement of interracial marriage. State senator E. O. Eddins skewered the author and the state library's director. The latter, who agreed to limit access to the book but not to ban it outright, eventually resigned over the incident.

The Story of Little Black Sambo, Dumpy Books for Children, no. 4
Helen Bannerman
London: Grant Richards, 1903, 8th edition (1899)
3.5" x 5"
Kerlan Collection, Children's Literature Research Collections, University of Minnesota Libraries

Based on a story the Scottish author improvised for her children while living in India, this book enjoyed largely unquestioned popularity in its first decades. Then, as the issue of racial equality became more central to American politics, it became a symbol of racial stereotyping and one of children's literature's most controversial books.

In the 1930s, Harlem Renaissance poet Langston Hughes and American librarians voiced objections to Helen Bannerman's illustrations and use of a name with pejorative connotations. But in 1949, The New York Public Library's Augusta Baker recommended *The Story of Little Black Sambo* in her landmark "Books About Negro Life for Children," albeit reluctantly, noting the "lack of material" for young children of color. A decade later, the situation having improved somewhat, Baker dropped the book from her updated roster. Beginning in the 1950s, copies were increasingly removed from American public libraries. Today, Bannerman's book enjoys widespread popularity only in Japan, where it is not viewed as racist.

Little Black Sambo (L & R)
Gustaf Tenggren, illustrator
original cover art and interior spread
watercolor and gouache on board
cover: 10" x 14", spread: 12.5" x 6.5"
Kerlan Collection, Children's Literature Research Collections, University of Minnesota Libraries

Off the Shelf: Giving and Getting Books

The Story of Little Babaji
Helen Bannerman; Fred Marcellino, illustrator
New York: HarperCollins, 1996
6.5" x 6.5"
Kerlan Collection, Children's Literature Research Collections, University of Minnesota Libraries

Two re-imaginings of *The Story of Little Black Sambo* made near-simultaneous appearances in 1996: Julius Lester and Jerry Pinkney's *Sam and the Tigers* and this interpretation by graphic artist and illustrator Fred Marcellino. Marcellino came to the project with fond childhood memories of Bannerman's text, and with the realization that key details of the narrative—the presence of tigers, the reference to ghee (Indian style clarified butter)—seemed clearly to point not to an African setting for the tale, but rather to an Indian one.

Sam and the Tigers
Julius Lester; Jerry Pinkney, illustrator
New York: Dial Books, 1996
10.75" x 10"
Kerlan Collection, Children's Literature Research Collections, University of Minnesota Libraries

The African American collaborators responsible for this complete recasting of Helen Bannerman's *The Story of Little Black Sambo* had very different childhood experiences of the original. Julius Lester had grown up a minister's son in the 1940s segregationist South and soon learned to recognize racist stereotypes in Bannerman's illustrations and the title character's name. Jerry Pinkney, in contrast, had been raised in Philadelphia, in a far less racially charged environment. As a boy, he treasured his copy of *Little Black Sambo* as the only picture book he owned that depicted a child of color. In this newly illustrated retelling, not only Sambo but every other character as well is renamed Sam, in a bold stroke that makes a clean break with an otherwise memorable story's tumultuous past.

Off the Shelf: Giving and Getting Books

138 Off the Shelf: Giving and Getting Books

And Tango Makes Three
Justin Richardson and Peter Parnell; Henry Cole, illustrator
New York: Simon & Schuster Books for Young Readers, 2005
11" x 8.5"
Kerlan Collection, Children's Literature Research Collections, University of Minnesota Libraries

The ninth entry in the American Library Association's 2017 list of the top ten challenged and banned books is no stranger to censorship. *And Tango Makes Three* has appeared on the list a whopping eight times—in 2017, 2014, 2012, 2010, 2009, 2008, 2007, and 2006—for challenges that mostly distill down to the book's depiction of a same-sex relationship between penguins ("unsuited to age group," "anti-family," and the head-scratching accusation of being "anti-ethnic" have also popped up in challenges).

Emile
Tomi Ungerer
New York: Harper, 1960
8.4" x 11"
Kerlan Collection, Children's Literature Research Collections, University of Minnesota Libraries

Emile
Tomi Ungerer
process art, pen and ink on paper
20" x 13.5"
Kerlan Collection, Children's Literature Research Collections, University of Minnesota Libraries

The Beast of Monsieur Racine
Tomi Ungerer
New York: Farrar, Straus and Giroux, 1971
9.75" x 12.5"
Kerlan Collection, Children's Literature Research Collections, University of Minnesota Libraries

Tomi Ungerer grew up during the 1940s along the war-torn French-German border and adopted an outsider's stance that prepared him well for a career in satirical illustration. In New York in the mid-1950s, he applied his talents to advertising, editorial illustration, and picture-book making. Together with Maurice Sendak, he soon emerged as one of the latter field's most provocative figures.
Ungerer enjoyed hiding surprises in his illustrations: an octopus with seven tentacles, or a man with a hole in his skull. The goal was always to amuse children and shock grown-ups. *The Beast of Monsieur Racine* is the story of two costumed youngsters who trick adults into believing they are a rare creature, prompted letters of complaint from parents. Ungerer's forays into erotic art further tarnished his reputation in the juvenile field and resulted in numerous bans by libraries.

Off the Shelf: Giving and Getting Books 139

THE ART
OF THE
PICTURE
BOOK

As the market for children's books expanded and matured, publishers developed a keener understanding of their audience. Among the increasingly well-defined genres that emerged as a result was the picture book, catering to the capacities and interests of younger, often preliterate children.

Early picture books were of necessity printed in black and white, with color sometimes added afterward by hand. By the mid-1800s, however, industrial-age wizardry had rendered color printing feasible. Talented artists—led by England's Walter Crane, Kate Greenaway, and Randolph Caldecott—flocked from the allied realms of satirical illustration, printmaking, and graphic design to seize a new chance to make their mark.

The genre evolved rapidly via bold experimentation with media, formatting, typography, paper, and a highly distilled approach to writing that, in the hands of a master like Margaret Wise Brown, approximated poetry. It continues to mature as an art form, even merging on occasion with the graphic novel, which has done much to explode the myth that older children—and adults—outgrow illustration. As digital publishing advances, the picture book and its natural ally, the artist's book, look increasingly like the laboratory where the future of the printed book will be decided.

A Master of Motion: Randolph Caldecott

The artist who invented the modern picture book grew up in the English Midlands, where at 15 he went to work as a "quill-driv[ing]" bank clerk. Caldecott preferred to draw, however, and from doodling on deposit slips, he leapfrogged to London and a flourishing career as a caricaturist for *The Graphic* and *Punch*.

Along with contemporaries Eadweard Muybridge and the inventors of early animation devices like the praxinoscope, Caldecott was obsessed with motion and speed. A master at depicting action in a few pen strokes, he enjoyed drawing while riding onboard fast-moving trains. Hired in 1878 to create a series of aesthetically ambitious children's picture books, Caldecott reimagined the long-static genre as a kinetic new art form whose graphics and page designs pulse with the boundless energy of children at play, and anticipate the coming of that most modern of Industrial Age cultural innovations—the motion picture.

The Diverting History of John Gilpin
(from *R. Caldecott's Collection of Pictures & Songs*)
Randolph Caldecott
London: Frederick Warne & Co. Ltd., 1896 (1878)
8.5" x 9.25"
Kerlan Collection, Children's Literature Research Collections, University of Minnesota Libraries

This stirring but also richly comic illustration of a man astride a runaway horse is the image reprised in bronze on the Caldecott Medal (see p. 119). It exemplifies the artist's knack for pressing drawing to the point of animation. Maurice Sendak, the 1964 Caldecott Medal recipient for *Where the Wild Things Are*, especially prized this aspect of the artist's work: "The word *quicken*, I think, best suggests the genuine spirit of Caldecott's animation, . . . the surging swing into action that I consider an essential quality in pictures for children's books."

THE DIVERTING HISTORY
OF
JOHN GILPIN:

Showing how he went farther than he intended, and came safe home again.

WRITTEN BY Wm COWPER — WITH DRAWINGS BY R. CALDECOTT

JOHN GILPIN was a citizen
 Of credit and renown,
A train-band captain eke was he,
 Of famous London town.

John Gilpin's spouse said to her dear,
 "Though wedded we have been
These twice ten tedious years, yet we
 No holiday have seen.

"To-morrow is our wedding-day,
 And we will then repair
Unto the 'Bell' at Edmonton,
 All in a chaise and pair.

"My sister, and my sister's child,
 Myself, and children three,
Will fill the chaise; so you must ride
 On horseback after we."

The Art of the Picture Book 143

A Apple Pie
Kate Greenaway
London: George Routledge & Sons, 1886
10.9" x 8.75"
Kerlan Collection, Children's Literature Research Collections,
University of Minnesota Libraries

Kate Greenaway and Randolph Caldecott, who were casual acquaintances and more or less friendly rivals, both produced picture books for Edmund Evans, an innovative English color printer and entrepreneur who earlier in his career had engaged the services of Walter Crane. For this volume based on a traditional alphabet rhyme, Greenaway created some of her most amusing and animated depictions of beautifully dressed, middle-class Victorian children at play.

Stuff and Nonsense
A. B. Frost
London: George Routledge & Sons, circa 1884.
8.3" x 10.75"
Kerlan Collection, Children's Literature Research Collections, University of Minnesota Libraries

A dynamic American line artist and cartoonist, A. B. Frost produced a series of sequential slapstick drawings in the late 1870s that anticipated by a decade or more the invention of the comic strip. Frost had recently returned from a two-year cartooning trip to London, where he almost certainly would have seen Randolph Caldecott's much-talked-about picture books, and could easily have met Caldecott and his cartoonist friends. In this drawing and limerick, he pokes spritely fun at the audacity of a photographer—Eadweard Muybridge, of course—for presuming to teach real artists the truth about horses by mechanical means.

Motion study of a horse from *Animal Locomotion*
Eadweard Muybridge, circa 1878
Library of Congress Prints and Photographs Division; http://hdl.loc.gov/loc.pnp/cph.3a45870, Public Domain, https://commons.wikimedia.org/w/index.php?curid=88447

Like Randolph Caldecott, English-born American photographer Eadweard Muybridge embraced the late Victorian artist's quintessential challenge of stopping time and capturing motion on canvas or the printed page. Muybridge undertook his motion experiments at the behest of railroad magnate Leland Stamford, a horse-racing enthusiast who wished to determine once and for all whether a galloping horse ever had all four of its legs off the ground at once. Employing a stop-action camera of his own devising, Muybridge proved decisively—as in the sequence shown here—that they did. He went on to produce an encyclopedic analysis of animals and humans in motion that was thereafter studied by artists—Caldecott most likely among them.

The Art of the Picture Book 145

A Frog he would a-wooing go,
 Heigho, says ROWLEY!
Whether his Mother would let him or no.
 With a rowley-powley, gammon and spinach.
 Heigho, says ANTHONY ROWLEY!

A Frog He Would A-Wooing Go
Randolph Caldecott
London: Frederick Warne & Co. Ltd., 1883
9.6" x 8.35"
Kerlan Collection, Children's Literature Research Collections, University of Minnesota Libraries

It was a departure for Randolph Caldecott to undertake a story featuring animal characters in human dress, and the change suited the caricaturist well. When new, this sprightly book was such a success at the home of one London family that its patriarch, Rupert Potter, a lawyer and art collector, purchased three of the illustrator's originals. Potter's 17-year-old daughter, Beatrix, was then still an aspiring artist. She studied the Caldecotts, and later demonstrated their impact on her as the creator of Peter Rabbit, Jemima Puddleduck, and, in particular, a waistcoated frog of her own devising named Jeremy Fisher.

The Tale of Mr. Jeremy Fisher
Beatrix Potter
London and New York: Frederick Warne & Co., 1906
4.25" x 5.75"
Kerlan Collection, Children's Literature Research Collections,
University of Minnesota Libraries

Sing A Song for Sixpence
Randolph Caldecott
London: George Routledge & Sons, 1880
8.5" x 9.25"
Kerlan Collection, Children's Literature Research Collections, University of Minnesota Libraries

Randolph Caldecott continually invented new ways to enliven the printed page. Here, anticipating a cinematic device, the dynamic scene on the left-hand page fast-forwards to the scene on the right. Viewers are impelled to make the leap across time in their own imaginations, even as the king's courtiers hasten onward to deliver their pie.

148 The Art of the Picture Book

Yankee Doodle: An Old Song 1775
Howard Pyle
New York: Dodd, Mead and Company, 1881
9.6" x 10.6"
Kerlan Collection, Children's Literature Research Collections, University of Minnesota Libraries

Howard Pyle, who mentored N. C. Wyeth and Jessie Willcox Smith, among many others, and is generally considered to be the "father of American illustration," here pays homage to Caldecott with an unmistakable nod to the comic hijinks of the latter artist's *Three Jovial Huntsmen*.

A Homespun Expressionist: Wanda Gág

The modern American picture book starts with Wanda Gág. The eldest daughter of struggling Bohemian immigrant artists, Gág (rhymes with "fog") grew up in New Ulm, Minnesota, where her family's defiantly nonconformist ways rendered them local pariahs. Even as a child, however, she never doubted her creative calling, which her father confirmed on his deathbed when he declared, "What Papa has left undone, Wanda will have to do." In 1917, Gág moved to New York, supporting herself as a commercial artist. She drew for the leftist publication *New Masses*, mastered lithography, and began exhibiting her prints in galleries. Her distinctive homespun, expressionistic style caught the eye of an editor keen to challenge the primacy of the British picture-book classics Americans prized. Critics hailed Gág's *Millions of Cats*, with its blend of folkloric and modernist influences, as a landmark achievement: exhilarating proof that in cultural attainments, as in industrial and military might, the American Century had indeed begun.

Portrait of Wanda Gág
Robert Janssen Gelatin
silver print, 1934
Special Collections and Rare Books,
University of Minnesota Libraries

By 1940, the artist was no longer writing original stories and had turned instead to making books from her own meticulous translations of traditional tales. Two years earlier, for example, at the instigation of Anne Carroll Moore, Gág had published *Snow White and the Seven Dwarfs* as a pointed rebuttal to the creative liberties taken by Walt Disney in his film based on the same story.

Snippy and Snappy
Wanda Gág
New York: Coward-McCann, 1931
Process art
Kerlan Collection, Children's Literature Research Collections,
University of Minnesota Libraries

Gág produced this mystery-laden domestic interior scene in the same period that she published her third picture book, *Snippy and Snappy*. The involvement of artists of Gág's caliber in picture book making greatly enhanced the visibility of the art form, and led in 1937 to the establishment of the Caldecott Medal for distinguished work by an American illustrator.

Lamplight
Wanda Gág
Lithograph, 1929
Minnesota Historical Society

The Art of the Picture Book 151

MILLIONS OF CATS

Millions of Cats
Wanda Gág
New York: Coward-McCann, Inc., 1928
Kerlan Collection, Children's Literature Research Collections,
University of Minnesota Libraries

"A child will almost feel that he has made this book," wrote Anne Carroll Moore in the *New York Herald-Tribune*, a ringing endorsement that was seconded by many. *The Nation* chose *Millions of Cats* as the only children's book on its list of 1928's most distinguished books, and *The Publishers' Weekly* declared that Gág's "coming to children's books is a high compliment to this field of literature." The following year, the American Library Association awarded Gág a Newbery Honor—its second-place literature prize, as it did not yet have an award for illustration to give her.

But then he saw a fuzzy grey kitten way over here which was every bit as pretty as the others so he took it too. And now he saw one way down in a corner which he thought too lovely to leave so he took this too.

Millions of Cats
Wanda Gág
process art, (top, R)
8.5" x 5.75"

Cats on a Blanket (opp, top R)
Wanda Gág
charcoal on sandpaper, ca. 1930s
6" x 7.8"

Cats on a Tripod (opp, bottom L)
Wanda Gág
charcoal on sandpaper, ca. 1930s
8" x 6"

First version - 2 y[ea]r[s] of Dele in m[anuscript]
revisions of W.G. in 1928

WANDA GAG
527 EAST 78
NEW YORK

MILLIONS OF CATS.

Once upon a time there was a very old man and a very old woman.

They lived in a nice clean house, which had flowers all around it, except where the door was. But they couldn't be happy because they were ~~so~~ very lonely.

"If we only had a cat," ~~sighed~~ the very old woman. ¶ "A cat?" asked the very old man.
"I will get you a cat, my dear," said the very old man, ¶ "yes, a sweet little fluffy cat" said the very old woman.

And he set out over the hills to look for one.
He climbed over the sunny hills
He trudged through the cool valleys

~~and he set out over the hills to look for one.~~
He walked a long, long time and at last he found a hill quite covered with cats.

Cats here,
Cats there,
Cats and kittens everywhere.
Hundreds of cats, thousands of cats, millions and billions and trillions of cats!

"Oh," cried the old man joyfully, "Now I can choose the prettiest cat and take it home with me."

So he chose one. It was white.

But just as he was about to leave he saw another white ~~one~~ one, all black and it which seemed just as pretty as the first.

So he took this one also.

But then he saw a ~~gray~~ one way over there which was every bit as pretty as the ~~ones he had in his arms,~~ others so he took ~~this~~ it too.

And now he saw one ~~over here~~ way down in a corner he thought too lovely to leave which ~~was black and very beautiful.~~ So he took ~~it.~~ this too

And just then, ~~over in that~~ corner, the ~~saw~~ a gray and white v.o.m. found a kitten which was so lovely ~~one which he thought too lovely to leave,~~ so he took ~~that it.~~ "It would be a shame to leave this one," said the v.o.m.

And ~~then,~~ in that corner, he saw a ~~kitten~~ which had yellow and brown stripes like a baby tiger. "I simply must take it," he said, and he did.

So it happened that every time ~~he~~ v.o.m. looked up, he saw another ~~one~~ cat which was so pretty he could not bear to leave it, and before he knew it, he had chosen them all!

And so he went back over the hills to show all his pretty kittens to the very old woman. It was very funny to see all those hundreds and thousands and millions and billions and trillions of cats following him!

They came to a pond.

"Mew, mew! We are thirsty," cried the hundreds ~~and~~ but thousands ~~and~~ millions and billions and trillions of cats. ¶ "Well, here is a great deal

~~They~~ Each took a sip of water and the pond was gone! ¶

"Mew, mew! Now we are hungry!" said the hundreds ~~and~~ thousands ~~and~~ millions and billions and trillions of cats.

"There is much grass on the hills," said the very old man.
Each cat ate a mouthful of grass and not a blade was left!
Pretty soon the very old woman saw them coming.

"My dear," she cried, "What are you doing? I asked for one little cat, and you are bringing hundreds and thousands and millions and billions and trillions of them."

"I know," said the very old man, looking at the sheet of cats behind him, "But each was as beautiful as the next so I had to take them all."

Story first told to Joann (Anker)
+ John (Huntington)
Spring 1922 (?)

Millions of Cats
Wanda Gág
New York: Coward-McCann, Inc., 1928
process art: blues, pen and ink
9" x 6.75" (top), 9" x 6.75" (center), 5" x 5" (bottom)
Kerlan Collection, Children's Literature Research Collections,
University of Minnesota Libraries

Millions of Cats Manuscript
Wanda Gág
New York: Coward-McCann, Inc., 1928
8.5" x 11" (opp)
Kerlan Collection, Children's Literature Research Collections,
University of Minnesota Libraries

The Size and Shape of Things

The picture book is one of the graphic arts' most dynamic creative laboratories. Faced with the extreme challenge of communicating with a preliterate—and at times even preverbal—audience, practitioners of this deceptively simple art form have continually reassessed every element of the book's physical makeup and design for its expressive and playful potential.

Be it a book as elephantine as an elephant (*The Story of Babar*), or as wee and soft to the touch as its elfin protagonists (*Little Fur Family*), or even one punched through with a hole tracking its hero's journey (*The Very Hungry Caterpillar*), concrete experiments like these are a perfect match for early childhood's primary focus on sensory-based learning. At the dawn of the digital age, they also spotlight one of the picture book's traditional strengths: its capacity not only to convey but also to embody a narrative in a palpably satisfying, perhaps even primal way.

Histoire de Babar, le petit elephant (The Story of Babar, the Little Elephant)
Jean de Brunhoff
Paris: Jardin des Modes, 1931
10.9" x 15"
Kerlan Collection, Children's Literature Research Collections, University of Minnesota Libraries

A painter by training, de Brunhoff entered the children's book world almost by chance, after his wife, Cécile, improvised a bedtime story for their two sons. The boys insisted their father illustrate the tale, which was set partly in their home city of Paris. When the artist's brother and brother-in-law, publishers of the deluxe fashion magazine *Le Jardin des modes*, had a look at the resulting homemade album, they insisted on publishing it for the trade.
The bittersweet tale of an orphaned elephant's new life appeared in a suitably elephantine trim, with the text handwritten in de Brunhoff's own charming cursive script. An immediate commercial success, the book was soon recognized, in France and beyond, as a model of graphically bold and playful picture book design.

Inch by Inch
Leo Lionni
New York: Ivan Obelensky Inc., 1960
9.7" x 11"
Kerlan Collection, Children's Literature Research Collections, University of Minnesota Libraries

Little Blue and Little Yellow
Leo Lionni
New York: Ivan Obelensky Inc., 1960 (1959)
8.5" x 8.25"
Kerlan Collection, Children's Literature Research Collections, University of Minnesota Libraries

As a graphic artist and the art director of *Fortune* magazine, Leo Lionni was a leading figure in New York's flourishing post–World War II design scene. Like many of his contemporaries, he came to the picture book serendipitously, in his case after improvising a story to distract his grandchildren during a train ride. With no art supplies at hand, Lionni turned bits of colored paper torn from a magazine into "characters." *Little Blue and Little Yellow* was the first of many Lionni picturebook fables notable for their playful philosophical reflections. For instance, in another of his stories, *Inch by Inch,* a caterpillar learns the importance of using one's wits in a world of big, hungry creatures, including some too large even to fit on the page.

The Art of the Picture Book 157

The Very Hungry Caterpillar
Eric Carle
New York: World Publishing Company, 1969
12" x 8.5"
Kerlan Collection, Children's Literature Research Collections, University of Minnesota Libraries

Like the caterpillar in the story, this well-loved picture book underwent a major metamorphosis, having begun life as a manuscript of uncertain promise titled "A Week with Willi Worm." Eric Carle was a successful commercial artist when he decided, in midlife, that he would rather make picture books than ads for pharmaceutical companies. Carle, like his friend and one-time mentor Leo Lionni, approached the picture book as a playground for graphic experimentation, as a chance to "squeeze as much as possible out of the paper." As he once told an interviewer, "That is how the designer in me came to do holes."

The Very Hungry Caterpillar - Japanese
Eric Carle
Contributor, Sentaro Morikubo,
Tokyo: Kaiseisha, 1989
Kerlan Collection, Children's Literature Research Collections, University of Minnesota Libraries

The Very Hungry Caterpillar - French
Eric Carle
New York: Philomel Books, 1992
Kerlan Collection, Children's Literature Research Collections, University of Minnesota Libraries

My Very First Book of Colors
Eric Carle
New York: Thomas Y. Crowell Company, 1974
4.9" x 6.8"
original art- collage and painted paper
5.8" x 4.15" (Butterfly)
Kerlan Collection, Children's Literature Research Collections,
University of Minnesota Libraries

Collage paper samples, Eric Carle
Acrylic on rice paper, undated
10.45" x 9.8" (top L)
Kerlan Collection, Children's Literature Research Collections,
University of Minnesota Libraries

Eric Carle first made hand-painted, rainbow bright papers like these as a student at Stuttgart's Academy of Art and Design. "We . . . would cut or tear [them] into pieces and arrange [them] in mostly abstract patterns," Carle recalls. "The idea was to train our sense of shape and color and design."
As a picture book artist, Carle returned to collage and handcolored papers as a visual storytelling medium. One reason for his books' extraordinary appeal is the fact that children recognize a direct connection between Carle's bold, bright pictures and the art they themselves make in preschool and kindergarten.

The Art of the Picture Book 159

The Slant Book
Peter Newell
New York: Harper & Brothers, 1910
8.2" x 10.25"
Kerlan Collection, Children's Literature Research Collections,
University of Minnesota Libraries

Turn-of-the-century illustrator Peter Newell had no use for the bohemian life. A proud family man, he once noted, "Some of my best work has been done while I had a baby on my lap." An amateur magician who enjoyed surprising his young audiences, Newell invented some of the most offbeat picture-book formats as well. Holes punched through the pages of his first books traced the paths of a stray bullet and of a rocket prankishly launched in a basement. He chose *The Slant Book*'s trapezoidal trim to mirror the angle of a runaway baby carriage's madcap downhill descent.

Little Fur Family
Margaret Wise Brown; Garth Williams, illustrator
New York: Harper & Brothers, 1946
4.5" x 6"
Kerlan Collection, Children's Literature Research Collections, University of Minnesota Libraries

Only a writer as in demand during the postwar Baby Boom years as Margaret Wise Brown could have persuaded a publisher to wrap a book in real rabbit's fur. Brown was a larger-than-life personality, but caprice was not the motivating factor here. Rather, she knew from her Bank Street studies—and the example of *Pat the Bunny*—that young children are intensely sensory beings who would just as soon pet and cuddle with a book as see and hear it. Brown also was sure that small children would love a fur-covered book as much as their own pets—a point confirmed by letters from parents, one of which tells of a preschooler who gave the book to her cat as a present and another of a child who tried to feed the book his supper.

The Art of the Picture Book

You must be sure to find the right size,
Il faut bien sûr trouver la bonne taille

Not too long, not too short, or the crocodile w
Pas trop long, pas trop court, sinon le crocodile va

rattle around in the LONG CROCODILE CASE;
ballotter dans la LONGUE CAISSE A CROCODILE;

Crocodile Tears (Larmes de crocodile)
André François
Paris: Robert Delpire; New York: Universe Books, 1956
10.7" x 3.5"
Kerlan Collection, Children's Literature Research Collections, University of Minnesota Libraries
Interior illustrations used with permission from Enchanted Lion Books

A contemporary of fellow *New Yorker* artist and Romanian émigré Saul Steinberg, the Paris-based André François (born Farkas) was a virtuoso at the drafting table, with endless comedic surprises up his sleeve. In the droll volume shown here, editions of which were published in 17 countries, he mimics the exact look of an airmail parcel for a slipcase housing a crocodile-shaped book about a crocodile. The story's tongue-in-cheek purpose is to reveal the true meaning of "crocodile tears." Maurice Sendak, Jules Feiffer, and Quentin Blake are among the picture-book artists to have been inspired by François's devil-may-care élan.

The Art of the Picture Book 163

The New Leonardo: Bruno Munari

Picasso called him "the new Leonardo," and no wonder: the Milan-based artist Bruno Munari repeatedly broke new ground as a painter, sculptor, industrial and graphic designer, writer, illustrator, educator, and philosopher during a career that spanned 70 years. Aligning himself in the 1920s with Futurism, an artistic and social movement that celebrated the speed, energy, and technological advancement of modern life, Munari grew to prefer creative work that enhanced the quality of daily experience. He declared, "When the objects we use every day, and the surroundings we live in have become in themselves works of art, then we shall be able to say that we have achieved a balanced life."

Fascination with the book as a portable art form was a constant of Munari's life-long quest for innovation. After World War II, as a new father, he turned his attention from Futurism to the future and made the first of many radically designed, imagination-stretching books for children: 10 ingeniously paper-engineered volumes that playfully demolish the line between sculpture, image, toy, and book.

L'uomo del camion (The Truck Driver)
Bruno Munari
Milan: Mondadori, 1945
process art
19" x 12.25"
Kerlan Collection, Children's Literature Research Collections, University of Minnesota Libraries

Bruno Munari broke with Futurism in the 1940s. The Futurists had high-flown ideals of the book being a "reading machine;" here, Munari embraces the more lighthearted concept of the picture book as a toy. In a series of 10 groundbreaking books published in Italy in 1945 and afterward in England, France, and the United States, Munari probed the genre's physical potential, incorporating different-sized pages, art concealed behind paper doors, and even books-within-books to lure prereaders to literacy. Never a confident writer, Munari crafted simple storylines in amusing, gamelike structures. In *L'uomo del Camion* (titled *The Birthday Present* in the U.S. edition), a deliveryman bearing a gift for a child changes vehicles repeatedly in descending size order from truck to roller skates.

bicicletta. Monta sulla bicicletta e via!
Ma ogni tanto la bicicletta
perde la catena. Marco si stanca
di rimetterla sempre a posto,
smonta la bicicletta
e tira fuori un

Km
7

tira fuori un'auto. Monta sull'auto e via!
Ma al nono chilometro l'auto si ferma.
Marco scende dall'auto, la smonta
e tira fuori una

Km
9

The Art of the Picture Book 165

Lothar Meggendorfer's Internationaler Circus
Lothar Meggendorfer
Esslingen Germany: Verlag J.F. Schreiber, 2006 (1877), reprint
3.8" x 5.7"
Kerlan Collection, Children's Literature Research Collections, University of Minnesota Libraries

Books with movable elements have a long and surprising history. The earliest known examples were produced in the 14th century as visual aids to advance study of anatomy, astronomy, and even theology. Victorian advertisers used pop-ups to sell stoves; landscape architects, to elucidate their designs for students and clients. Toward the end of the 19th century, as the market for illustrated gift books swelled, the potential for pop-ups as entertaining juvenile fare was realized as well.
The foremost artist/designer to seize the opportunity was Lothar Meggendorfer, a Munich-based satirical illustrator. As exemplified by this remarkable novelty, first published in Germany in 1887, Meggendorfer's robust comic characters and the waggish animated pratfalls he devised for them anticipate the slapstick comedy of silent-film clowns like Charlie Chaplin and Buster Keaton.

The Genius of Lothar Meggendorfer, A Movable Toy Book
Lothar Meggendorfer; Maurice Sendak, Introduction
London: Intervisual Communications, Inc., 1985
9" x 12"
Gift to the Kerlan Collection from Lauren Stringer

166 The Art of the Picture Book

The Wheels on the Bus, (A Book with Parts that Move), 10th Anniversary Special Edition
Paul O. Zelinsky
New York: Dutton, 2000 (1990)
11.25" x 7.75"
Kerlan Collection, Children's Literature Research Collections,
University of Minnesota Libraries

The Wheels on the Bus, (A Book with Parts that Move)
pencil on layered paper
process art used with permission of the artist

The Art of the Picture Book 167

VIRGINIA LEE BURTON'S
LITTLE HOUSE

THE LITTLE HOUSE

HER STORY

BY VIRGINIA LEE BURTON

The Little House
Virginia Lee Burton
Boston: Houghton Mifflin, 1942
cover art: tempera on board, 22" x 10.5" (previous pages)
Kerlan Collection, Children's Literature Research Collections,
University of Minnesota Libraries

The Little House
Virginia Lee Burton
process art: pencil, tempera and watercolor on paper
Little House: spring, 9.6" x 8.9" (opp, top L)
Little House: night, 9.7" x 6.35" (opp, top R)
Little House: at home, 9.4" x 8.8" (opp, center L)
Little House: autumn, 10" x 8.3" (opp, center R)
Little House: city lights, 9.2" x 8.5" (opp, bottom L)
Little House: returning, 9.7" x 8.4" (opp, bottom R)
Little House end papers, 20" x 9.35" (top)
Little House:city, 20.6" x 9.75" (bottom)
Kerlan Collection, Children's Literature Research Collections,
University of Minnesota Libraries

A Child's Good Night Book
Margaret Wise Brown; Jean Charlot, illustrator
New York: William R. Scott, 1943
5.75" x 6.8"
Kerlan Collection, Children's Literature Research Collections,
University of Minnesota Libraries

Taking their cue from Beatrix Potter's mantra—"little books for little hands"—Jean Charlot and Margaret Wise Brown crafted this diminutive bedtime book in which one by one, everything and everyone—fish, bunnies, children—go to sleep.
Charlot, a French-Mexican artist, spent the 1920s painting murals alongside Diego Rivera. Like Brown, he later embraced the picture book in part because he sensed a clear connection between the directness and candor of the folk art that inspired him and young children's natural mode of expression.

Let it Shine, Three Favorite Spirituals
Ashley Bryan
New York: Atheneum Books for Young Readers, 2007
10.3" x 11.6"
Kerlan Collection, Children's Literature Research Collections,
University of Minnesota Libraries

Ashley Bryan made his first books as a child enrolled in a Depression-era WPA program in Harlem. The creative freedom he experienced then sparked a lifelong exploration of art and storytelling traditions and of media. Bryan's books have introduced generations of young readers to African folklore and to vital aspects of African American culture, including the spirituals dramatized here. While a concern for tradition has played a motivating role in nearly all his books, Bryan is an unconventional illustrator of the first order. The pages of this book, ecstatically colored collages rendered with construction paper, all but defy words and instead, quite appropriately, evoke the energy and excitement of music and dance.

Strega Nona
Tomie DePaola
New York: Simon & Schuster Books for Young Readers, 1975
8" x 11"
original art, watercolor on paper, 7.5" x 2.7"
Kerlan Collection, Children's Literature Research Collections,
University of Minnesota Libraries

The Art of the Picture Book 173

Make Way for Ducklings
Robert McCloskey
New York: Viking, 1941
9.5" x 12.5"
Kerlan Collection, Children's Literature Research Collections, University of Minnesota Libraries

Based on a true story, the quintessential picture book about Boston was created in the Greenwich Village studio that Robert McCloskey shared with another future Caldecott Medal winner, Marc Simont. A stickler about naturalistic detail, McCloskey kept live ducklings in his studio bathtub for months as he sketched their movements and anatomy.

Corduroy
Don Freeman
New York: Viking Press, 1968
9.3" x 8"
Kerlan Collection, Children's Literature Research Collections, University of Minnesota Libraries

Corduroy
Don Freeman
process art: graphite and colored pencil
11.5" x 8.8"
Kerlan Collection, Children's Literature Research Collections, University of Minnesota Libraries

174 The Art of the Picture Book

Tuesday
David Wiesner
New York: Clarion Books, 1991
11" x 9"
Kerlan Collection, Children's Literature Research Collections, University of Minnesota Libraries

Randolph Caldecott enjoyed drawing galloping huntsmen as he whirred through the landscape in a fast-moving train. A century later, David Wiesner was on board a commercial jetliner when he made his first doodles of frogs in flight on magic-carpet lily pads. *Tuesday* continues Wiesner's investigation of the picture book as an all but completely visual narrative art form, a possibility earlier explored by Caldecott in full-dress picture books spun from such slender rhymes as "Hey, Diddle, Diddle" and "Baby Bunting."

Tuesday
David Wiesner
process art used with permission of the artist

From: DAVID WIESNER
Date: Fri, Sep 7, 2018 at 9:36 AM
Subject: Re: ABC of It: Why Children's Books Matter
To: Lisa Von Drasek

. . . Use as many or as few as you want. They are all related to page 22–23, the one with the dog.

The first two were from my sketchbook that I did on the fateful plane ride.
1. The quick "doodles" I did on the plane. These images came to me quickly and I put them down as fast as I could.
2. A blow up of the page 22 doodle.
3. This is the layout for the book. Took me about an hour. This is how I write, with pictures. As you can see, the whole book is here. Note in the top row that I made notations to change single images into multi-paneled images.
4. The final drawing. These pages are done after I gather my reference. I made clay models of the frogs, looked at night skies, and found a dog.
5. A detail of the final painting. Note the collar says, "Rusty." That is my editor's dog (Dorothy Briley). His name was Rusty."

The Art of the Picture Book

4

5

The Art of the Picture Book

The Stinky Cheese Man and other Fairly Stupid Tales
Jon Scieszka; Lane Smith, illustrator
New York: Viking, 1992
9" x 10.75"
Kerlan Collection, Children's Literature Research Collections, University of Minnesota Libraries

American picture-book artists of the Baby Boom generation grew up reading Sendak and Seuss while acquiring media savvy at an early age through steady exposure to television and advertising. The books these artists went on to create are notable for their merry-prankster irreverence and archly sophisticated sense of design. Epitomizing the trend is this spoof of classic fairy tales, and of books themselves as cultural artifacts. "Melting" lines of text, a misplaced title page, and collage mash-ups of standard-issue illustrations typify the winking wit at work—and play—here.

178 The Art of the Picture Book

The Stinky Cheese Man and other Fairly Stupid Tales
book dummy (opp page)
color proof (top L)
promotional materials (top R)
Jon Scieszka, original manuscript (bottom L)
Kerlan Collection, Children's Literature Research Collections,
University of Minnesota Libraries

The Art of the Picture Book

Pop Culture

As an art form notable for its indelible characters and well-turned plots, children's literature has long served as a trove of material for the performing arts and Hollywood. The earliest film versions of *The Secret Garden* and *The Wonderful Wizard of Oz* date from the Silent Era. The tradition of fashioning operas, ballets, dramas, and musicals on a fairy tale or storybook is older still. Who knew that a picture book, *The Story of Ferdinand*, could inspire not only an animated film but also symphonic treatment, a pop song, and a hairdo involving a hornlike flip?

Toys, games, dolls, clothing, and other commercially licensed spin-offs have had a similarly long and labyrinthine history. Decades before Disney, Lewis Carroll and Beatrix Potter authorized the manufacture of gift items inspired by their literary creations. To stabilize her hand-sewn Peter Rabbit prototype, Potter weighted the bunny's soft fabric form with lead shot—the very thing with which the gun-toting Farmer McGregor would gladly have pulverized Peter!

Adding to its pop-cultural legacy are the memorable catch-phrases and images that have seeped from children's literature into the vernacular. Like Alice wandering through Wonderland, we deem the inexplicable in our own world "curiouser and curiouser," and thanks to the Harry Potter books, we now have the perfect word—muggles—for the unmagical (or, more broadly, boorish) people we might meet in our travels. And as a sure-fire metaphor for any fall from grace, Humpty Dumpty remains forever at our beck and call.

Wizard of Oz Film Still (opp, top L)
Directed by Larry Semon
American silent film, 1925

Poky Little Puppy Plush Toy and Cup (opp, top R)
Kerlan Collection, Children's Literature Research Collections, University of Minnesota Libraries

Ferdinand the Bull Poster (center L)
Poster from the Federal Theatre Project,
Work Projects Administration production, 1937
https://commons.wikimedia.org/wiki/File:Ferdinand_the_Bull.jpg

The Wonderful Game of Oz (center)
Oz-themed gameboard
Salem, MA: Parker Brothers, 1921

Goodnight Moon Plush Toy and Board Book
(center - R)
New York: Harper Festival, 2005

Tuesday Frog Plush Toy (bottom L)
MerryMakers
Kerlan Collection, Children's Literature Research Collections, University of Minnesota Libraries

The Wizarding World of Harry Potter (bottom R)
advertisement for Harry Potter World

180 The Art of the Picture Book

The Art of the Picture Book 181

Humpty Dumpty

An egg with a human face? The English nursery rhyme that introduced Humpty Dumpty—popular archetype of the doomed or hapless hero—is itself quite short on physical description, and for good reason. Long before the days of illustrated Mother Goose collections, this witty rhyme started out as a riddle.

"Humpty Dumpty" first appeared in print in England in 1797, in Samuel Arnold's *Juvenile Amusements.* Lewis Carroll archly embellished the character in *Through the Looking-Glass,* as James Joyce would again do in *Finnegans Wake.* Nineteenth-century American actors George L. Fox and Tony Denier won fame and fortune milking the role for slapstick laughs, and illustrators from John Tenniel to Charles Addams scrambled to refresh our image of the mock-tragic figure. So ingrained in our collective psyche has "Humpty Dumpty" become that cultural icons and iconoclasts from Aretha Franklin ("All the King's Horses") to Bob Woodward and Carl Bernstein (*All the President's Men*) have adapted its memorable catchphrases for their varied purposes.

Mother Goose, or the Old Nursery Rhymes (Humpty-Dumpty)
Kate Greenaway
New York: Gramercy Publishers, 1978 (1881)
3.9" x 6.2"
Kerlan Collection, Children's Literature Research Collections, University of Minnesota Libraries

Humpty-Dumpty, Through the Looking-Glass
Lewis Carroll; John Tenniel, illustrator
London: Macmillan, 1872 (1871)
5.7" x 7.9"
Kerlan Collection, Children's Literature Research Collections, University of Minnesota Libraries

Humpty-Dumpty, Mother Goose
Frederick Richardson
Volland Popular edition, 1915
8.4" x 11.5"
Kerlan Collection, Children's Literature Research Collections, University of Minnesota Libraries

The Wonderful Adventures of Humpty Dumpty
Thomas Nast
New York: McLoughlin Bros., 1890 (1869)
5.85" x 8"
Kerlan Collection, Children's Literature Research Collections, University of Minnesota Libraries

After The Fall
Dan Santat
Roaring Brook Press, 2017
8.5" x 11"
Kerlan Collection, Children's Literature Research Collections, University of Minnesota Libraries

The Art of the Picture Book 183

The Tall Book of Mother Goose
Feodor Rojankovsky, illustrator
New York: Harper & Brothers, 1942
5.5" x 12.8"
Kerlan Collection, Children's Literature Research Collections,
University of Minnesota Libraries

Russian-born artist Feodor Rojankovsky illustrated this novelty-formatted book of nursery rhymes soon after fleeing Nazi-occupied Paris for New York. With his caricatured depiction of Humpty Dumpty sporting an Adolf Hitler mustache, Rojankovsky forecast a bad end for the German dictator. Postwar editions of this perennially strong seller retained the image, even after Rojankovsky revisited the book in 1965 and replaced an illustration of a nanny that had drawn criticism for being a stereotypical depiction of a woman of color.

184 The Art of the Picture Book

Mary Poppins

Raised in Australia by the stern but caring aunt who later inspired her most famous character, P. L. Travers began her literary life as a poet and spiritual seeker in the London circle of William Butler Yeats, George William Russell, and James Stephens. Travers wrote *Mary Poppins* in her thirties, while convalescing from an illness. Her subsequent denials that she ever wrote for children reflected both the second-class status of "juvenile authors" in her day and her aversion to allowing either children or herself to be pegged. Travers reluctantly agreed to the 1964 big-screen adaptation that became a Disney box-office triumph, launched Julie Andrews's film career, and brought the author herself undreamed-of wealth, albeit at the cost of seeing her starchy, quasi-mythological heroine made over with a heaping spoonful of sugar. Despite her qualms, she later pressed Disney for a sequel and a musical, the latter of which finally opened on Broadway in 2006, a decade after Travers's death.

Mary Poppins
P. L. Travers; Mary Shepard, illustrator
London: G. Howe, 1934
4.95" x 7.5"
Kerlan Collection, Children's Literature Research Collections, University of Minnesota Libraries

Mary Poppins
P. L. Travers; Júlia Sardà, illustrator
Boston: HMH Books for Young Readers, 2018
7.8" x 9.25"
Kerlan Collection, Children's Literature Research Collections, University of Minnesota Libraries

The Art of the Picture Book

The Secret Garden

"With the best I have in me, I have tried to write more happiness into the world." So declared Frances Hodgson Burnett, looking back on her run as the late Victorian era's most popular female author. Born in England and raised in Tennessee by her widowed mother, Burnett was best known during her lifetime for *Little Lord Fauntleroy*, a Dickensian rags-to-royalty novel about an American every-child who proves to be an English nobleman's heir. Its phenomenal success sparked a craze for dressing schoolboys in black velvet and lace, and made Burnett rich.

Two failed marriages and the death of a son propelled Burnett on the spiritual quest that culminated in *The Secret Garden*. "When you have a garden," she wrote, "you have a future." Her contemporaries were unsure what to make of the tough-minded tale about two damaged but ultimately resilient youngsters. Subsequent, more psychologically savvy generations, however, have judged it her masterpiece, and the one Burnett book that perennially cries out to filmmakers, illustrators, and others.

The Secret Garden
Frances Hodgson Burnett; MinaLima Ltd., illustrator
New York: Harper Design, an Imprint of
HarperCollins Publishers, 2018 (1911)
6.4" x 9.4"
Gift from JoAnn Jonas

Frances Hodgson Burnett wrote swiftly and confidently, a habit acquired in youth when she sold her first stories to help support her widowed mother and family. "My object is remuneration," the writer, still in her teens, had boldly informed the first magazine editor to be offered her work. Two actual gardens served as backdrops for the writing of this manuscript. Burnett had her first inklings of the novel while working at her writing table in the rose garden at Great Maytham Hall, the manor house in Rolvenden, Kent, that she had made her home in 1898 after initiating divorce proceedings against her first husband. She later composed the book while laying out the garden and grounds of her next and last home, in Plandome Manor, New York.

The Art of the Picture Book　　187

The Wizard of Oz

L. Frank Baum had been a dismal flop as an actor, chicken farmer, newspaper editor, and traveling salesman when, as a family man in his forties, he turned his hand to writing for children—and found his vocation. W. W. Denslow was one of Chicago's best-known illustrators when the two men met and became fast friends. Denslow approached the illustrations for *The Wonderful Wizard of Oz,* their second collaboration, as a series of dynamic, posterlike images. Each is drawn with the artist's trademark wit in a dashing calligraphic line that crackles with conviction.

The original Oz book was an instant success, and inspired a popular 1902 Broadway musical, numerous sequels by Baum and others, the classic 1939 MGM film, the 1978 adaptation *The Wiz,* and the Broadway phenomenon of the last decade, *Wicked.* Commenting on his life's work, Baum would say:

"To write fairy stories for children, to amuse them, to divert restless children, sick children, to keep them out of mischief on rainy days, seems of greater importance than to write grown-up novels. Few of the popular novels last the year out, responding as they do to a certain . . . characteristic of the time; whereas, a child's book is, comparatively speaking, always the same, since children are always the same, . . . with the same needs to be satisfied."

The Wonderful Wizard of Oz
L. Frank Baum; W.W. Denslow, illustrator
Chicago: Reilly and Lee Company, 1900
6.5" x 8.9"
front cover: top, back cover bottom, interior illustrations, opposite page
Oz Collection, Children's Literature Research Collections, University of Minnesota Libraries

The Art of the Picture Book 189

The Story of Ferdinand

It took the author less than an hour, on a rainy October Sunday in 1935, to pen the story he would spend the rest of his life explaining. Munro Leaf, a debonair New York publishing executive, later claimed that he wrote *The Story of Ferdinand*—the tale of a bull who refuses to fight—simply to give his illustrator-friend Robert Lawson an opportunity to "let loose." He chose a bull for his protagonist, he said, because bunnies and mice were already taken. When *The Story of Ferdinand* appeared in print the following year, the Spanish Civil War had begun—and the book was immediately seized upon as a political allegory, becoming a much-talked-about best seller. Some critics called its "don't fight" message pro-Franco, even as Franco banned the book in Spain. Hitler called it "degenerate;" Stalin, pro-Communist; and Gandhi, pro-pacifist. Walt Disney purchased the film rights, and in 1938 his *Ferdinand the Bull* took the Oscar for best animated short, powering one of the first blockbuster product-licensing campaigns.

The Story of Ferdinand
Munro Leaf; Robert Lawson, illustrator
New York: Viking, 1936
7.15" x 8.3"
Kerlan Collection, Children's Literature Research Collections, University of Minnesota Libraries

Like Wanda Gág's *Millions of Cats* a decade earlier, *The Story of Ferdinand* was greeted by librarians and critics as a milestone work in the aesthetic development of the American picture book. When controversy erupted over its possible intent as political allegory, Anne Carroll Moore was quick to jump to the book's defense, declaring it, in her column for *The Horn Book* magazine, an "effortless, carefree collaboration . . . designed for the sheer entertainment of the ageless."

The Story of Ferdinand
Munro Leaf; Robert Lawson, illustrator
book dummy and process art: pencil, ink, and watercolor on paper
7" x 8.34"
Used with permission from The Free Library of Philadelphia

The Art of the Picture Book

Harry Potter

In the summer of 1998, advance copies of a preteen fantasy by an unknown Scottish writer began landing on American reviewers' doorsteps. A publisher's letter predicted great things for the debut work, and for once the hype was wildly understated. By series volume three, Harry Potter was logging global sales of forest-rattling proportions. Movie deals tumbled into place, and *The New York Times* spun on a separate juvenile best-seller list aimed at keeping the world safe for the usual potboilers and thrillers.

What fueled the frenzy? At first, word of mouth—greatly amplified by new online booksellers—and the deftness with which J. K. Rowling melded so many of children's literature's classic themes. *Harry Potter* was both a boarding-school comedy and an orphan's quest; high fantasy and budding romance. It was Roald Dahl without the crustiness, or J. R. R. Tolkien with a time-out for a game of Quidditch. Whatever its secret and against all odds, the series left an entire generation of media-savvy youngsters—and more than a few of the world's grown-ups—spellbound by the old-fashioned magic of storytelling.

Harry Potter and the Philosopher's Stone
J. K. Rowling; Thomas Taylor, illustrator
London: Bloomsbury, 1997
5" x 7.95"
Kerlan Collection, Children's Literature Research Collections, University of Minnesota Libraries

Harry Potter and the Sorcerer's Stone
J. K. Rowling; Mary Grandpre, illustrator
New York: Arthur A. Levine Books, Scholastic, 1997
6" x 9"
Kerlan Collection, Children's Literature Research Collections,
University of Minnesota Libraries

Bound galleys of J. K. Rowlings's debut novel went out to reviewers in the summer of 1998 before the book was formally published in the United States. Anxious about its then-unprecedented outlay of $100,000 for North American rights to the book, the American publisher, Scholastic, sought to hedge its bets by altering the title from the original *Harry Potter and the Philosopher's Stone* to one that sounded less highbrow. A letter addressed to industry insiders brashly predicted that publishing history was about to be made and that the advance galley would itself one day become a prized collectible—as indeed it has.

Harry Potter and the Sorcerer's Stone
J. K. Rowling; Brian Selznick, illustrator
New York: Arthur A. Levine Books, Scholastic, 2018

The Art of the Picture Book

Comics Grow Up: Graphic Novels

In 1969, John Updike wrote, "I see no intrinsic reason why a doubly talented artist might not arise and create a comic-strip novel masterpiece." Updike would see his prediction come true less than a decade later with the publication of Will Eisner's pioneering graphic novel, *A Contract With God*.

The graphic novel, a swiftly developing, high-low cultural hybrid, has a many-stranded past. Major influences include the caprices of 19th-century European caricaturists; the dazzling sketchbooks of Hokusai and, subsequently, Japanese manga (comic-strip narratives); and the underground comix that culminated in Art Spiegelman's *Maus*. The triumph of *Maus* allowed a generation of artists to pursue far-flung ideas and personal obsessions. Increasingly, many have done so in books with special appeal for young readers. As a more grown-up version of comics, the graphic novel has proven to be an art form ideally suited to the coming-of-age story, as in Craig Thompson's *Blankets*. For beginning and "reluctant" readers, these illustrated books can be gateways to literacy as well.

A Contract with God and Other Tenement Stories
Will Eisner
New York: W.W. Norton & Co., 2006 (1978)
7" x 10"
Wilson Library, University of Minnesota Libraries

Will Eisner made his first landmark contribution to the comics tradition as the creator of *The Spirit*, a fastidiously drawn, noir-ish strip about a masked vigilante crime fighter. *The Spirit* ran in Sunday supplements from 1940 to 1952.
In the 1970s, Eisner experimented with long-form comics. In 1978, Baronet Books published his *A Contract with God*, which is often cited as the first modern American graphic novel. It inaugurated a series of similar works examining the trials and tribulations of New York City's immigrant communities.

Maus: A Survivor's Tale
Art Spiegelman
New York: Pantheon Books, 1986
6.5" x 9"
Kerlan Collection, Children's Literature Research Collections, University of Minnesota Libraries

A leading figure of the 1960s underground comix movement, Art Spiegelman first published *Maus* as a serialized insert in *Raw*, the avant-garde magazine he co-published with artist and designer Françoise Mouly. The artist received a special Pulitzer Prize for *Maus* (volumes 1 and 2) in 1992, which proved to be a galvanizing moment for the graphic novel as an art form, conferring mainstream legitimacy on the genre and doubtless encouraging legions of younger practitioners to pursue their dreams.

Will Eisner: A Dreamer's Life in Comics
Michael Shumacher
New York: Bloomsbury USA, 2010
6.4" x 9.6"
Donated to the Kerlan Collection by Lisa Von Drasek

The Art of the Picture Book

The Arrival
Shaun Tan
New York: Arthur A. Levine Books, Scholastic, 2007
9.5" x 12.8"
Kerlan Collection, Children's Literature Research Collections, University of Minnesota Libraries

An Australian artist of Chinese heritage, Shaun Tan adds a phantasmagorical dimension to the classic scenario of an immigrant's bittersweet departure from his home country and his arrival in a strange new land. In this wordless, comics-style narrative, rows of small sepia-tone drawings of colossal cities and looming beasts suggest images preserved in an old photo album—documentary proof, Tan implies, of an experience so unsettling that it must be seen to be believed.

The Invention of Hugo Cabret
Brian Selznick
New York: Scholastic, 2007
5.85" x 8.6"
Kerlan Collection, Children's Literature Research Collections, University of Minnesota Libraries

In *The Invention of Hugo Cabret*, Brian Selznick blended elements of the graphic novel and children's picture book in an evocative hybrid work that memorializes the genesis of another experimental art form, the motion picture.

Blankets
Craig Thompson
Marietta, Ga.: Top Shelf, 2003
6.5" x 9.35"
Kerlan Collection, Children's Literature Research Collections, University of Minnesota Libraries

Craig Thompson joined the first rank of graphic novelists with this, his critically acclaimed second book. An autobiographical coming-of-age story, *Blankets* recounts a Midwestern teenager's struggle to balance, or choose between, his family's fundamentalist Christianity, his talent for drawing, and his love for his girlfriend.
Thompson is widely admired for his graceful draftsmanship and credited with helping move the graphic novel beyond the obsessive self-absorption that was among its early hallmarks.

Boxers and Saints
Gene Luen Yang
First Second Books, 2013
6.1" x 8.1"
Kerlan Collection, Children's Literature Research Collections, University of Minnesota Libraries

American Born Chinese
Gene Luen Yang
New York: First Second, 2006
5.6" x 8.3"
Kerlan Collection, Children's Literature Research Collections, University of Minnesota Libraries

The Art of the Picture Book 197

BABY MOUSE
QUEEN OF THE WORLD!

Baby Mouse: Queen of the World
Jennifer L. Holm and Matthew Holm
New York: Random House Books for Young Readers, 2005
5.6" x 7"
 process art: pencil and ink on paper, 10.9" x 8.5" (this page)
 process art: ink and digital, 14" x 8.3" (opp, top)
 original art: 14" x 8.3" (opp, bottom)
Kerlan Collection, Children's Literature Research Collections,
University of Minnesota Libraries

Storied City: New York

"To some people," sighs the worldly, wisecracking 12-year-old Peter Hatcher of Judy Blume's *Superfudge*, "there's no place like Nu Yuk. And I guess I'm one of them." As America's real-life Oz, "Cross-roads of the World," and publishing epicenter, New York City remains an enduring source of inspiration for authors of books for children and teens.

Mark Twain, Frances Hodgson Burnett, Ludwig Bemelmans, H. A. and Margret Rey, Langston Hughes, Robert McCloskey, Roald Dahl, Maurice Sendak, and Blume herself all called New York home at one time or another. Providing more than mere residency, however, New York and its culture of superlatives—its tall tale–ish appetite for newests, biggests, and bests—has made it a natural backdrop for the exploits of colorful characters, from *Eloise* and *Harriet the Spy* to *Lyle Crocodile*. In the same spirit, writers and artists have celebrated the city's iconic landmarks; chronicled its historic role as a seaport, arts mecca, and immigrant destination; and zoomed in tightly on its endlessly evolving honeycomb of culturally diverse neighborhoods. New York's openness to change is doubtless the main reason it has inspired its own flourishing subgenre of young people's literature, with stories to tell about growing up, venturing out, and becoming one's own person.

In the Night Kitchen
Maurice Sendak
New York: Harper & Row, 1970
8.6" x 11"
Kerlan Collection, Children's Literature Research Collections, University of Minnesota Libraries

By his own account, winning the 1964 Caldecott Medal for *Where the Wild Things Are* freed Maurice Sendak to explore bold new directions for the picture book. In this, his next major contribution to the genre, he turned in part to vintage comic strips for stylistic inspiration, a decision sure to raise eyebrows among traditionalists who still considered the comics trash. The real provocation lay elsewhere, however: in his frontal depiction of a naked boy. Reports of fig leaves or their equivalent being pasted in place by decorous librarians were soon pouring into Harper & Row's offices, prompting Sendak's editor, Ursula Nordstrom, to publish an open letter addressed to the juvenile-book community, condemning an "act of censorship by mutilation rather than by obvious suppression," and declaring that such behavior "must not be allowed to have an intimidating effect on creators and publishers of books for children."

Tar Beach
Faith Ringgold
New York: Crown Publishers, Inc., 1991
9.35" x 12.5"
Kerlan Collection, Children's Literature Research Collections, University of Minnesota Libraries

The title of this book, which is set in the 1930s Harlem of the artist's childhood, refers to the tar-covered tenement rooftops where neighborhood residents traditionally gathered in search of relief from the summer heat. The illustrations derive from Ringgold's monumental story quilt of the same name. Wiry eight-year-old Cassie Louise Lightfoot imagines herself being lifted by the stars and soaring high above the city's sweltering streets and the bejeweled George Washington Bridge. Images of flight have deep roots in African American folklore, originally as a metaphor for release from the oppression of slavery.

The Block
Langston Hughes; Romare Bearden, illustrator
New York: Viking, 1995
9" x 12.35"
Kerlan Collection, Children's Literature Research Collections, University of Minnesota Libraries

These powerful illustrations of Harlem neighborhood life are segments of a 1971 six-panel collage by Romare Bearden, and were paired for this book with poems by the artist's contemporary Langston Hughes. Hughes, like Bearden, was a leading figure in the Harlem Renaissance. Although the poet did not compose these lyrics with young readers in mind, accessibility and unadorned truth telling were always high on his aesthetic agenda, and from his very first appearance in print, in the April 1921 issue of *The Brownies' Book* magazine, Hughes considered writing for the younger generation a priority.

Eloise
Kay Thompson; Hilary Knight, illustrator
New York: Simon & Schuster, 1955
8.5" x 11.7"
Kerlan Collection, Children's Literature Research Collections,
University of Minnesota Libraries

Pert, unpredictable Eloise was to six-year-old girls of the 1950s what Holden Caulfield was to their older brothers: "our ticket," recalls journalist Marie Winn, "out of the gray flannel society . . . a clarion call, a preview of the 1960s sensibility." More than a half century later, the doughty young heroine of this rather sophisticated tale set in the Plaza Hotel remains one of New York's most famous imaginary residents.

James and the Giant Peach
Roald Dahl; Nancy Ekholm Burkert, illustrator
New York: Alfred A. Knopf, 1961
6" x 9.35"
Kerlan Collection, Children's Literature Research Collections,
University of Minnesota Libraries

In this fable by the author of *Matilda,* first published in 1961, a monster peach with a lonely boy riding inside rolls out of an English garden and into the world. Borne aloft by seagulls, the peach makes it all the way across the Atlantic. After first being mistaken for an incoming enemy bomb—in 1961, the Cold War was, after all, at its peak—the peach finally comes to rest atop the Empire State Building's television needle, and the boy inside emerges to a hero's welcome.

Harriet the Spy
Louise Fitzhugh
New York: Harper & Row, 1964
5.6" x 8.25"
Kerlan Collection, Children's Literature Research Collections, University of Minnesota Libraries

If Max, the wee hero of *Where the Wild Things Are,* had an older sister, she might well look and act like rambunctious, 11-year-old Harriet M. Welsch. Louise Fitzhugh's protagonist, who lives with her parents and nanny in a fashionable Yorkville townhouse, dresses like a tomboy, sulks, swears, grouses, and commits minor acts of breaking and entering in the service of her dream of becoming a writer. Critics were unsure at first what to make of Harriet's uncompromising manner, but young readers were quick to identify with the funny, feisty rebel who wears her heart on her sweatshirt sleeve.

From the Mixed-up Files of Mrs. Basil E. Frankweiler
E. L. Konigsburg
New York: Atheneum, 1967
5.9" x 8.6"
Kerlan Collection, Children's Literature Research Collections, University of Minnesota Libraries

This irreverent novel, the 1968 Newbery Medal winner, chronicles the adventures of an enterprising brother and sister, Claudia (aged 12) and Jamie (aged 9), who hide out for a week in the Metropolitan Museum of Art. The book generated so much interest about the museum and its collections that at one time the Met maintained a special telephone hotline to respond to children's queries. No, young callers were patiently informed, it is never possible to sleep over in Marie Antoinette's bed!

The Art of the Picture Book 203

All-of-a-Kind Family
Sydney Taylor; Helen John, illustrator
Chicago: Wilcox and Follett, 1951
7.5" x 9.4"
Kerlan Collection, Children's Literature Research Collections, University of Minnesota Libraries

A sort of Lower East Side *Little Women,* this episodic novel set in the year 1912 dramatizes the daily routines and holiday observances of a first-generation Jewish American family with five daughters. Taylor based her first novel and its four sequels on memories of growing up in lower Manhattan and the Bronx. She modeled Sarah, the middle child, on herself.

All-of-a-Kind Family
Sydney Taylor
original manuscript with edits
Kerlan Collection, Children's Literature Research Collections, University of Minnesota Libraries

204 The Art of the Picture Book

145th Street: Short Stories
Walter Dean Myers
New York: Delacorte, 2000
6" x 8.7"
Kerlan Collection, Children's Literature Research Collections, University of Minnesota Libraries

The celebrated author of a wide array of books for children and teens about the African American experience, Walter Dean Myers grew up in Harlem in the 1940s. The 10 stories in this collection were directly inspired by Romare Bearden's collage *The Block*, now in the collection of the Metropolitan Museum of Art.

145th Street: Short Stories
Walter Dean Myers
original manuscript with edits
Kerlan Collection, Children's Literature Research Collections, University of Minnesota Libraries

The Art of the Picture Book 205

Stevie
John Steptoe
New York: Harper & Row, 1969
6.5" x 8.75"
Kerlan Collection, Children's Literature Research Collections, Univeristy of Minnesota Libraries

John Steptoe was a Brooklynite still in his teens when his high school art teacher sent him to meet the visionary director of Harper Junior Books, Ursula Nordstrom. Nordstrom had published *Goodnight Moon*, *Charlotte's Web*, *Where the Wild Things Are*, and countless other ground-breaking books. Would she see the talent in this young man of color as well? Few children's books of the time featured African American characters and themes, and Nordstrom was anxious to redress the imbalance. She welcomed Steptoe and helped him shape this powerful first book about a New York foster child and his new family. Steptoe was soon lionized as a civil rights–era wunderkind, interviewed in *Life* and on *The Today Show*. It was a role he shrank from. More rewarding by far were the responses of young readers, their teachers, and librarians.

Mufaro's Beautiful Daughters
John Steptoe
New York: Lothrop, Lee & Shepard Books, 1987
9.5" x 11.25"
Kerlan Collection, Children's Literature Research Collections, University of Minnesota Libraries

The Art of the Picture Book

The Snowy Day
Ezra Jack Keats
New York: Viking, 1962
9.5" x 8.25"
Kerlan Collection, Children's Literature Research Collections,
University of Minnesota Libraries

This landmark work, winner of the 1963 Caldecott Medal, is one of the first American picture books to feature a child of color. It is set in an impressionistically rendered version of East New York, Brooklyn, where the artist, born Jacob Ezra Katz, spent his Depression-era childhood. Here, Peter enjoys a carefree day of playing—and grandly making his mark—in the snow. In subsequent books, Keats introduced readers to his young hero's friends and neighbors in an unprecedented exploration of the lives and dreams of inner-city New York children.

The Snowy Day
Ezra Jack Keats
Original art, 19.5" x 10"
Ezra Jack Keats Papers,
de Grummond Children's Literature Collection,
University of Southern Mississippi Libraries

The Art of the Picture Book 207

The Snowy Day
Ezra Jack Keats
original art, 19.5" x 10"
Ezra Jack Keats Papers,
de Grummond Children's Literature Collection,
University of Southern Mississippi Libraries

208 The Art of the Picture Book

The Art of the Picture Book 209

CODA:
FROM THE
KERLAN

When I first entered *The ABC of It* at The New York Public Library, I was wonderstruck. The phrase that came to mind was "we stand on the shoulders of giants."

First as a bookseller, then as a publishing assistant, then as a public librarian, a school librarian, an instructor of teachers, and now the curator of the Children's Literature Research Collections, I have had a lifetime exploring children's books.

I have read widely about children's books and story. I could fill these pages with the names of those who have mentored me in how to read, see, and critically think about children's books and their creators.

Yet it was *The ABC of It,* an adventure park experience of children's literature, that placed all that I knew in fresh context, the *Why*. Why these volumes, these stories, these creators all mattered in my education, my teaching, and my living.

Many who read this volume might not know two important facts about the Archives and Special Collections of the University of Minnesota Libraries.

First, the majority of the materials held in the Children's Literature Research Collections are generously donated by the writers and artists for research and education.

Second, the University of Minnesota is an open access institution that welcomes all visitors to our collections.

This coda contains a small selection of contemporary works from the Kerlan Collection that continue to express themes of *The ABC of It*. Children's literature is an art form that educates, entertains, challenges, and inspires.

—Lisa Von Drasek, Curator

Red Rubber Boot Day
Mary Lynn Ray; Lauren Stringer, illustrator
New York: Harcourt, 2000
10.6" x 9.4"
title page: acrylic on gessoed paper, 18" x 18"
cover art: acrylic on gessoed paper, 31.8" x 18"
cover study: pencil and ink on paper, 5.5" x 5"
Kerlan Collection, Children's Literature Research Collections, University of Minnesota Libraries

This poetic read-aloud continues the tradition of the "Here-and-Now" school. Ray's buoyant text and Stringer's energetic acrylic paintings perfectly capture an up-close child's eye view of indoor and outdoor rainy-day play. The cover illustration exemplifies the explosive joy of puddle jumping in contrast to the "almost cover's" expression of contemplation and longing gazes out the window.

212 Coda: From the Kerlan

Coda: From the Kerlan

A Chair for My Mother
Vera B. Williams
New York: Greenwillow Books, 1982
8.2" x 10.5"
process art, watercolor, 11.2" x 9.8"
Kerlan Collection, Children's Literature Research Collections, University of Minnesota Libraries

Vera B. Williams was a writer and illustrator for young people whose picture books, poetry, and novels centered on the lives of children and families at the bottom of the economic strata. Titles like *A Chair for My Mother*, *Scooter*, and *Amber Was Brave, Essie Was Smart* tackled topics rare for books of the period, including homelessness, cultural diversity, incarcerated parents, living in housing projects, and food insecurity. Ms. Williams drew on her own childhood experiences with deprivation and displacement, yet her characters and stories illuminate the resilience, community, and joy of living.

214 Coda: From the Kerlan

I Stink
Kate McMullan; Jim McMullan, illustrator
New York: HarperCollins, 2002
11" x 9"
process art: watercolor and ink on paper
Kerlan Collection, Children's Literature Research Collections,
University of Minnesota Libraries

The inheritors of the Virginia Lee Burton school of vehicles are the McMullans. If there was an award for child-centered, unique voice in a picture book, the McMullans' *I Stink* would get it in a New York minute. A day in the life of a personified garbage truck, readers revel in the tough guy attitude, they luxuriate in the stylized art, and giggle at the detailed garbage—including a pile of poop.

Coda: From the Kerlan

Balloons Over Broadway: The True Story of the Puppeteer of Macy's Parade
Melissa Sweet
Boston: Houghton Mifflin Harcourt, 2011
11" x 9"
process art: collage, section
21.5" x 16.25"
Kerlan Collection, Children's Literature Research Collections, University of Minnesota Libraries

The Sibert Award given by the American Library Association is for best informational book of the year. *Balloons Over Broadway* is a biography full of facts and wonder. Sweet imagines Tony Sarg's creative process through the images of Humpty Dumpty and all of his parts on this process art page.

Hands
Lois Ehlert
San Diego: Harcourt, 1997
10.2" x 5.2"
Kerlan CollectionChildren's Literature Research Collections, University of Minnesota Libraries

Waiting for Wings
Lois Ehlert
San Diego: Harcourt, 2001
book dummy (below): pencil and pen on paper
original art (next page): painted paper collage, 17" x 11"
Kerlan Collection Children's Literature Research Collections, University of Minnesota Libraries

Ehlert harks back to the shape books as she experimented with the physical container of the pages: *Hands* is in the shape of her father's yellow work glove. Over the years, the pages of her books have included cutouts, spyholes, flaps that lift, and die-cut shapes that form into other figures. Ehlert plays with dimensions, page-turning surprises, and, in *Waiting for Wings*, transformation. Her meticulous research of the natural world results in an accuracy of scale, from the tiny details of flower petals to the size of a monarch's wingspan.

Coda: From the Kerlan

Dance
Bill T. Jones and Susan Kuklin; Susan Kuklin, illustrator
New York: Hyperion Books for Children, 1998
9" x 11"
Kerlan Collection, Children's Literature Research Collections, University of Minnesota Libraries

Researchers. We use that label for anyone exploring our collections. Researchers can be PhD candidates, 5th-grade students on a field trip, a scout troop, or librarians. No matter who they are, we can sense the excitement in our visitors as they begin to see the threads connecting our materials.

There are connections between a picture book biography about José Limón and the celebration of movement by Bill T. Jones and Susan Kuklin. As Jones said in an interview,

". . . I am what we once called a post-modern choreographer. We are the generation who came after Martha Graham, Merce Cunningham and José Limón. We were asking all of these questions such as: What is narrative? What is storytelling? What is the role of the artist, the person onstage, in relationship to the audience? These things are still being asked now."
Bill T. Jones, interview (https://cenhum.artsci.wustl.edu/features/Joanna-Dee-Das-Bill-T-Jones-Trauma-Endurance-Democracy-of-Dance)

José! Born to Dance
Susanna Reich; Raúl Colón, illustrator
New York: A Paula Wiseman Book, Simon & Schuster Books For Young Readers, 2005
8.5" x 11"
original art: watercolor, colored pencil, lithograph pencil
9.75" x 12.25"
Kerlan Collection, Children's Literature Research Collections, University of Minnesota Libraries

Dark Day, Light Night
Jan Carr; James Ransome, illustrator
New York: Hyperion Books for Children, 1995
8" x 10"
original art: oil on paper, 15" x 10"
Kerlan Collection, Children's Literature Research Collections, University of Minnesota Libraries

Children need to see themselves in their books. Rudine Sims Bishop, PhD, is one of the giants in children's literature scholarship. Dr. Bishop developed the *Mirror and Windows* theory of book selection. Young readers need books that reflect their own lives and books that are windows into the lives, languages, and cultures of other children. Dr. Bishop has taught generations of caregivers, teachers, and librarians to read and think critically through the lenses of race and culture and to advocate for diversity in children's book publishing.

222 Coda: From the Kerlan

These Hands
Margaret H. Mason; Floyd Cooper, illustrator
Boston: HMCO, 2011
8.5" x 11"
original art: oil erasure
Kerlan Collection, Children's Literature Research Collections,
University of Minnesota Libraries

All Fall Down
Mary Brigid Barrett; LeUyen Pham, illustrator
Candlewick, 2014
6.8" x 7.1"
original art: digital
Kerlan Collection, Children's Literature Research Collections,
University of Minnesota Libraries

Coda: From the Kerlan 223

Amelia Bedelia
Peggy Parish; Fritz Seibel, illustrator
New York: Harper & Row, 1963
5" x 7"
book dummy: watercolor, pencil, and ink on paper,
13.5" x 9.5" (open)
Kerlan Collection, Children's Literature Research Collections, University of Minnesota Libraries

One of the first of the "early readers" after *The Cat in the Hat* (1957) was *Amelia Bedelia*. This housekeeper's misunderstanding of instructions caused her to draw pictures of drapes rather than close them and dress a chicken in a cunning outfit rather than prepare it for roasting. We readers might consider the eponymous character ignorant because of her errors. Instead let us consider that she may be an English language learner, for whom homonyms and homophones can be especially challenging.

224 Coda: From the Kerlan

Amelia Bedelia had just finished the chicken.
She heard the front door open.
"The folks are back," she said.
She rushed out to meet them.

Amelia Bedelia got some scissors.
She snipped a little here and a little there.
And she changed those towels.

Mrs. Rogers dashed into the bathroom.
"Oh, my best towels," she said.
"Didn't I change them enough?" asked Amelia Bedelia.

Coda: From the Kerlan

Ivy and Bean
Annie Barrows; Sophie Blackall, illustrator
San Francisco: Chronicle Books, 2006
5.8" x 7.5"
original manuscript page with edits
process art: ink and watercolor on paper
Kerlan Collection, Children's Literature Research Collections,
University of Minnesota Libraries

Young readers continue to be drawn to the familiar characters and settings of series books. Annie Barrows's words and Blackall's expressive pen and ink drawings capture the friendship of opposites in these award-winning early chapter books.

226 Coda: From the Kerlan

The Stupids Die
Harry Allard; James Marshall, illustrator
Boston: Houghton Mifflin Books for Young Readers, 1981
8.5" x 7.2"
process art: pencil on paper, 7.5" x 9.8"
Kerlan Collection, Children's Literature Research Collections, University of Minnesota Libraries

Humor is subjective. What makes a five-year-old giggle is different from what makes a fifty-year-old laugh, and the absurd humor of Grandfather Stupid saying "This isn't heaven. This is Cleveland." isn't for everyone. Many of James Marshall's books have appeared on lists of challenged and banned books, including—for language, premise, themes, and behavior—*The Stupids Die*. Nick Bruel's *Bad Kitty* series makes numerous lists of challenged books on the basis of his use of symbols like %#@$ to indicate explosive language, and an elementary school in Texas banned *Bad Kitty Christmas* for its brief mention of a lesbian couple.

Bad Kitty Meets the Baby
Nick Bruel
New York: Roaring Brook Press, 2012 (2011)
5.5" x 8"
process art: pen on paper, 8.5" x 11"
used with permission of the artist
Kerlan Collection, Children's Literature Research Collections, University of Minnesota Libraries

Coda: From the Kerlan 227

What the Heart Knows, Chants, Charms, & Blessings
Joyce Sidman; Pamela Zagarenski, illustrator
Boston: HMH Books for Young Readers, 2013
5.5" x 9.2"
Kerlan Collection, Children's Literature Research Collections, University of Minnesota Libraries

The archives hold the creative process of authors and illustrators. We can discover a poem by Joyce Sidman, "Invocation for Snow in Large Quantities" (draft at left), originally meant for the collection *What the Heart Knows*, but transformed instead into a picture book through the inspiration of editor Ann Rider. Illustrator Beth Krommes brought a whole new narrative to the project. Sidman wrote that she "was thrilled with the idea of a picture book using this poem;" and Krommes, when offered the chance to illustrate, "made the book her own, with completely original plot and characters." [*Before Morning*]

Before Morning
Joyce Sidman; Beth Krommes, illustrator
Boston: HMH Books for Young Readers, 2016
7.6" x 10"
Manuscript page with notes from author
process art: scratchboard, 5.8" x 7.6" (detail)
Kerlan Collection, Children's Literature Research Collections, University of Minnesota Libraries

228 Coda: From the Kerlan

Antler, Bear, Canoe: A Northwoods Alphabet Year
Betsy Bowen
Boston: Little, Brown and Company, 1991
10.2" x 9"
original art: woodblock print, 9.8" x 13"
Kerlan Collection, Children's Literature Research Collections,
University of Minnesota Libraries

A Fabulous Fair Alphabet
Debra Frasier
San Diego: Beach Lane Books, 2010
9.6" x 11"
original art: cut paper collage, 10.5" x 11.6"
Kerlan Collection, Children's Literature Research Collections,
University of Minnesota Libraries

Just as the the alphabet ends in Z, so does *The ABC of It*.

Coda: From the Kerlan 229

SUGGESTED READING

The following titles are just a small selection of the reference materials that inform the work of the Children's Literature Research Collections. To read these or any of the rare books, manuscripts, or process materials of the Archives and Special Collections, look at our on-line catalog and finding aids on the University of Minnesota Libraries' site, then email or call to make an appointment. We will have what you are interested in available in our reading room.

Arbuthnot, May Hill. *Children and Books*. Scott, Foresman, 1947.

Bader, Barbara. *American Picturebooks from Noah's Ark to the Beast Within,* New York: Macmillan, 1976.

Baker, Augusta. *Stories: a list of stories to tell and to read aloud.* 5th ed. rev. New York: New York Public Library, 1960.

Baker, Augusta, and Ellin Greene. *Storytelling: Art and Technique*. 2nd ed., Bowker, 1987.

Bauer, Caroline Feller. *Caroline Feller Bauer's New Handbook for Storytellers*. Illustrations by Lynn Gates. American Library Association Editions, 1993.

Bishop, Rudine Sims. *Free within Ourselves: The Development of African American Children's Literature.* Westport: Greenwood Press, 2007.

Huck, Charlotte S. and Barbara Kiefer. *Children's Literature in the Elementary School.* Boston: McGraw Hill, 2004.

Marcus, Leonard S. *Author Talk*. New York: Simon and Schuster Books for Young Readers, 2000.

Marcus, Leonard S. *Golden Legacy*. New York: Random House Children's Books, 2007.

Marcus, Leonard S. *Margaret Wise Brown: Awakened by the Moon,* Boston: Beacon, 1992.

Marcus, Leonard S. *Minders of Make-Believe: Idealists, Entrepreneurs, and the Shaping of American Children's Literature*. Houghton Mifflin Co., 2008.

Marcus, Leonard S. *Randolph Caldecott The Man Who Could Not Stop Drawing.* New York: Frances Foster Books, Farrar Straus Giroux, 2013.

Marcus, Leonard S. *Show Me A Story.* Somerville: Candlewick Press, 2012.

Marcus, Leonard S. *Sponsored by The Children's Book Council. 100 Years of Children's Book Week Posters.* New York: Alfred A. Knopf, 2019.

Pellowski, Anne, and Lynn Sweat. *The Story Vine: A Source Book of Unusual and Easy-to-Tell Stories from around the World.* Macmillan; Collier Macmillan, 1984.

Seale, Doris, and Beverly Slapin. *A Broken Flute: The Native Experience in Books for Children*. AltaMira Press; Oyate, 2005.

Sutherland, Zena, et al. *Children and Books*. 6th ed., Scott, Foresman, 1981.

Digital Resources from The Kerlan Collection. https://www.lib.umn.edu/clrc/digital-resources

Note:
Bibliographic data is for the title and edition on exhibit. The dates in parenthesis are the original publication dates. Full bibliographic data will be available in the digital exhibit on-line.

ACKNOWLEDGMENTS

This catalog would not have been created without the generous donations of time, talent, materials, and enthusiasm from all of the people who worked on it.

We wish to give special thanks to Lauren Stringer, Kerlan Friend extraordinaire, author and illustrator, who volunteered hundreds of hours designing this labor of love.

This volume would not exist without our project managers, Mary Schultz and JoAnn M. Jonas. Their knowledge of the Kerlan Collection, organizational skills, copy editing, and supervision of every aspect were invaluable.

With gratitude we acknowledge The New York Public Library, the originating institution of *The ABC of It*.

A special thanks to Susan Rabbiner of NYPL's Exhibition Department for facilitating the permissions process that made the CLRC exhibit possible.

There are not enough words for how grateful we are to the interns and volunteers of the Children's Literature Research Collections—Rebecca Brown, Lucy Comer, Lana Miller, Emma Peterson, Katie Retterath, Ellen Sugg, Joan Platt Broad, Jennifer M. Brown, Paula Singer (close reader extraordinaire)—and to the staff of the University of Minnesota Digital Services.

We are grateful for the donations and sharing of images from JoAnn M. Jonas, Lauren Stringer, Ellen A. Michelson, Paul O. Zelinsky, Melissa Sweet, David Weisner, Jerry Pinkney, Nick Bruel, The New York Public Library, The de Grummond Collection at the University of Southern Mississippi, and The Free Library of Philadelphia.

The ABC of It would not be possible without the financial support of The Kerlan Friends, Karen Nelson Hoyle, PhD, Ellen A. Michelson, Norma and Bernard W. Gaffron, Suzanne Karr Schmidt, PhD, the Ezra Jack Keats Foundation, Fred and Patricia Erisman, Gerald P. Barnaby, Helen R. Goldsmith, Marilyn Hollinshead, JoAnn M. Jonas, John W. Stewig, the Lerner Foundation, E. Eugene Peterson, Paul G. Heller, Kirstine Barnaby, Carol J. Erdahl, the Edythe Miller Family Trust, and many anonymous donors.

To support the work of the Children's Literature Research Collections, become a Kerlan Friend. https://www.lib.umn.edu/clrc/kerlan-friends.

Project managers JoAnn M. Jonas and Mary Schultz at work